POSTCARD HISTORY SERIES

# Southern West Virginia
# Coal Country

POSTCARD HISTORY SERIES

# Southern West Virginia
# Coal Country

James E. Casto

ARCADIA
PUBLISHING

Published by Arcadia Publishing
Charleston SC, Chicago IL, Portsmouth NH, San Francisco CA

Printed in the United States of America

Library of Congress Catalog Card Number: 2004104490

For all general information contact Arcadia Publishing at:
Telephone 843-853-2070
Fax 843-853-0044
E-mail sales@arcadiapublishing.com
For customer service and orders:
Toll-Free 1-888-313-2665

Visit us on the Internet at www.arcadiapublishing.com

# CONTENTS

# ACKNOWLEDGMENTS

Fortunately for those of us who love local history, people not only like to send and receive picture postcards, they like to save them as well. Stored in the attic, where they have been tucked away in Grandpa's old steamer trunk or Aunt Sally's tattered hatbox, vintage postcards can provide a remarkable look back at the way things were.

I have collected old postcards for years, buying them at yard sales, flea markets, antique shops, and most recently, on the Internet. If you think you might like to start a card collection, you will find that many interesting cards can be purchased for only a dollar or two apiece. But consider yourself warned. Other cards can sell for more, in some cases, much more. And yes, I should also warn you that card collecting can be highly addictive.

Much of the fun for me is learning more about the scenes I add to my collection. Much of what I have learned is passed on to you in this volume. The cards reprinted here do not represent a formal history of Southern West Virginia, but rather a scrapbook that offers some intriguing glimpses into the region's history. I appreciate the many people—too many to name—who have helped me in my collecting and research. I am in their debt.

# INTRODUCTION

The history of West Virginia is the history of coal. Especially during the industry's peak years from 1920 to 1950, when the number of people employed and the amount of capital invested in coal mining equaled that of all other industries in the state combined.

Most people think coal is a mineral. It is not. Coal is an organic compound formed from the remains of living trees, shrubs, and plants that flourished millions of years ago in swamp-like areas. When the plants died and fell into the boggy waters, they partially decomposed, but they did not rot. Instead, they changed into a slimy material we call peat. The sea advanced and receded and laid down new sediments. Under pressure, the peat dried and hardened into coal. Tremendous pressure might compress a 20-foot layer of plant material into a one-foot-thick seam of coal. Coal is a fossilized plant material—a rock that burns.

No state is more closely associated with coal and coal mining than West Virginia. Coal is found in all but two of the state's fifty-five counties. Mines in northern and central West Virginia produce anthracite coal similar to that found in Pennsylvania. Southern West Virginia has some of the world's richest deposits of low-sulfur bituminous coal.

In West Virginia's earliest years, most of the state's coal was consumed within a few miles of where it was mined. What was missing was a way to get the coal from mine to market. The coming of the railroads provided that missing link and, in the process, changed West Virginia forever.

The Baltimore & Ohio Railroad, whose tracks reached Wheeling in 1853, and the Chesapeake & Ohio Railway, which ran its first train from Richmond to Huntington in 1873, were the first railroads to traverse the state. Neither of them was built for the purpose of developing West Virginia's natural resources. Rather, they were built to link the Eastern cities with the Midwest. Both railways quickly pushed their tracks westward into Ohio and beyond. It was not until investors began building feeder lines, branching out from the B&O and the C&O, that the state's coal riches were tapped.

Later, new lines were laid out across Southern West Virginia with the express purpose of providing access to the region's coal deposits. The coming of the Norfolk & Western Railway (1881) and the Virginian Railway (1907) set off coal booms that turned sleepy little communities into bustling places. Coalfield communities—Bluefield, Beckley, Logan, Welch, Williamson, and others—boomed and the larger nearby cities of Huntington and Charleston prospered as gateways to and from the busy coalfields. It is not an exaggeration

to say that coal impacted the lives of nearly every resident in Southern West Virginia during these years.

The railroads not only hauled coal to market; they also brought in trainloads of workers. Because the state's Southern region was so sparsely populated, mine operators were forced to import labor. They brought in white Americans from other coal regions (carefully screened to keep out union organizers), black Americans from the South, and immigrants from a number of European countries. As a result, the southern coalfields developed a diverse population.

With the mines almost always located in remote, out-of-the-way locations, operators had to build housing for their workers and their families, company stores, schools, and churches. The worst of these were squalid "coal camps" of flimsy, tarpaper shacks, but many were attractive little towns, with comfortable housing, sidewalks, extensive recreational facilities, and other amenities.

Today, coal remains an important factor in the West Virginia economy, as evidenced by the long coal trains that still wind their way out of the state's hills and hollows. More than 99 percent of West Virginia's electricity is generated by coal. More than half of the nation's energy comes from coal—much of it dug in West Virginia. But today's high-tech mining requires only a fraction of yesterday's work force. Just as the coal industry has changed dramatically, so has Southern West Virginia. The old coal tipples and company stores are quickly disappearing, the victims of progress. This book provides a way of looking back and remembering what life was like in Coal Country, not so very long ago.

# One

# MINING MEMORIES

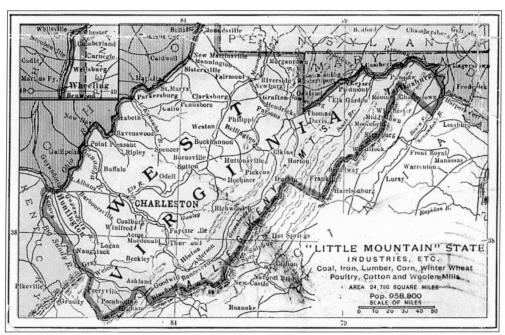

Here is a card, postmarked in 1908, with a map of West Virginia. Look at the map and locate the city of Huntington at the state's westernmost point, then draw an imaginary line east to Charleston and straight on to the Virginia border. The area south of that line is roughly the area depicted in this book.

This undated card is captioned "Coal Mining in Kanawha County," but the scenes shown could have been anywhere in Southern West Virginia during the boom years of the state's coal industry. Three mines operated in Kanawha County before the coming of the railroad. Once the railroad provided a means to get the coal to market, the number of mines in the county quickly grew to nearly 50.

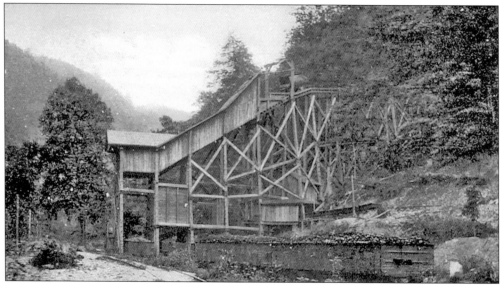

The caption on this undated card is "Coal Tipple, Charleston, W.Va.," but more than likely, it is a not a scene from Charleston proper. It is probably a scene from a few miles away in rural Kanawha County, perhaps the Cabin Creek area, which was home to a number of mines. Tipples were the structures into which the coal-laden mine cars were tipped when they came from the mine. The coal was then dumped into railroad cars waiting below.

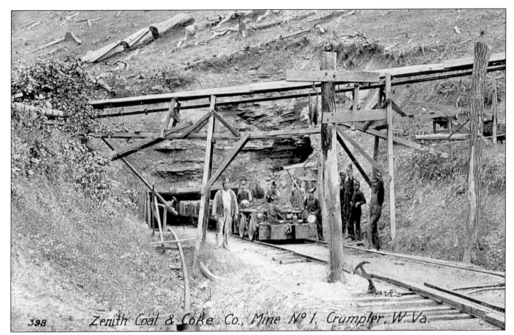

398    Zenith Coal & Coke Co., Mine Nº 1, Crumpler. W. Va.

This card, postmarked in 1907, shows a scene of the Zenith Coal & Coke Co. Mine No. 1 at Crumpler in McDowell County. A penciled note on the back of the card indicates it was sent from the nearby community of Big Four.

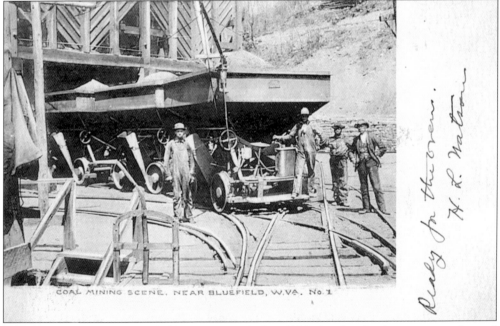

COAL MINING SCENE, NEAR BLUEFIELD, W.VA. No. 1

This mining scene near Bluefield was postmarked in 1908. As a handwritten note on the card indicates, this coal is "ready for the ovens," where it was turned into coke, a material used for steelmaking. The vast quantities of coking coal found in West Virginian helped make the United States the world leader in steelmaking.

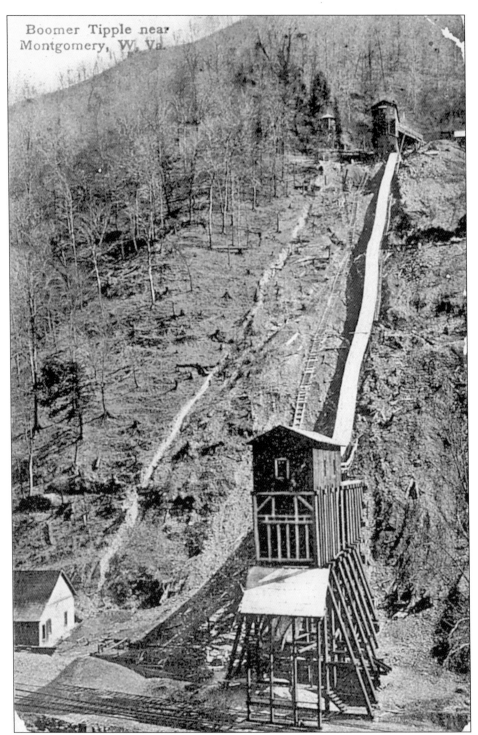

Boomer Tipple near Montgomery, W. Va.

Postmarked in 1909, this card shows the hillside tipple of a mine at Boomer near Montgomery in Fayette County. Like many early American postcards, this view was printed in Germany, known for its sophisticated printing techniques.

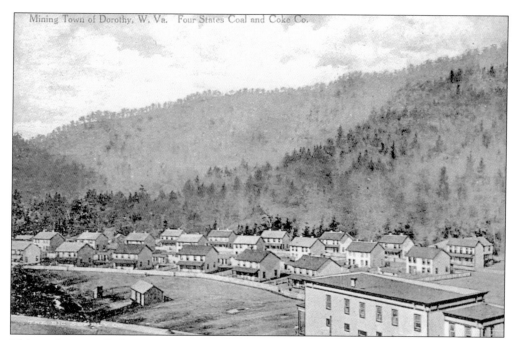

This card was mailed in 1912. The demands of a coal-hungry nation spawned mining towns in remote areas so rugged and uninviting that even Native Americans had avoided them. The Four States Coal and Coke Co. established the town of Dorothy on the Clear Fork of the Coal River in Raleigh County.

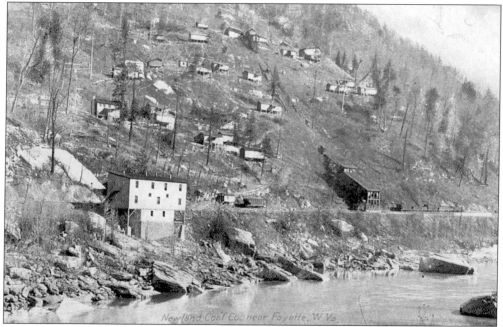

This undated view shows the Newland Coal Co. near Fayette, West Virginia. If you look closely, you can see a string of waiting railroad coal cars at the card's far right, just beyond the hillside tipple.

13

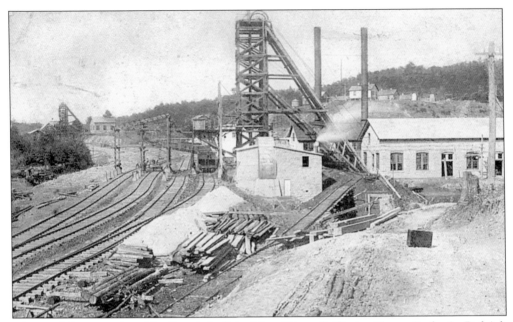

This card depicts Mines No. 5 and 6 of the New River Collieries Co. at Eccles in Raleigh County. Located on the Coal River, the mines at Eccles were served by both the Virginian Railway and the Chesapeake & Ohio Railway. In 1915, when this card was mailed, Eccles was a bustling community of 1,500 people.

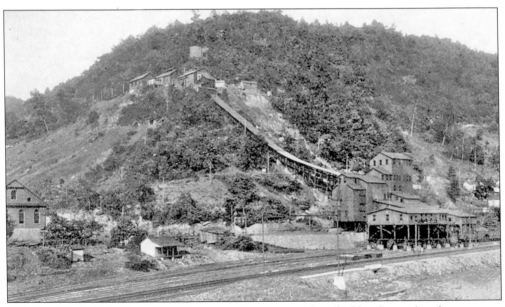

This coal tipple in McDowell County was otherwise unidentified by the card maker.

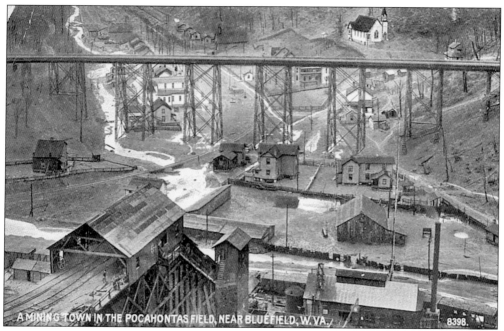

First mined in the 1890s, coal from West Virginia's Pocahontas field became the fuel of choice for the United States Navy, powering America's victory in the Spanish-American War and fueling the industrialization of a nation. The mine town shown on this 1908 postmarked card is in the Pocahontas field near Bluefield.

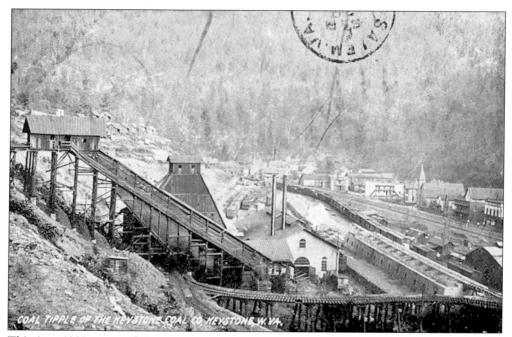

This is a 1907 view of the Keystone Coal Co. tipple at Keystone in McDowell County. Like many West Virginian mining towns, Keystone took its name from the company that mined there.

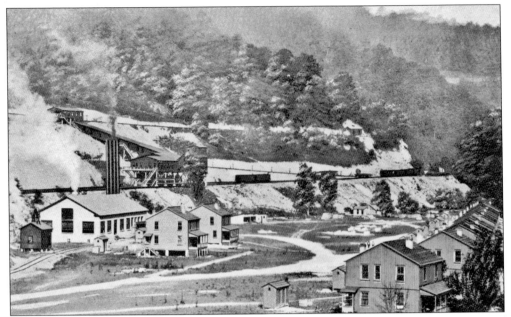

This is an undated view of a "Mining Camp, near Williamson." Note the symmetrical row of identical company-owned houses at the lower right of the card. In well-run coal towns, the houses were regularly painted and maintained. In others, they were often neglected.

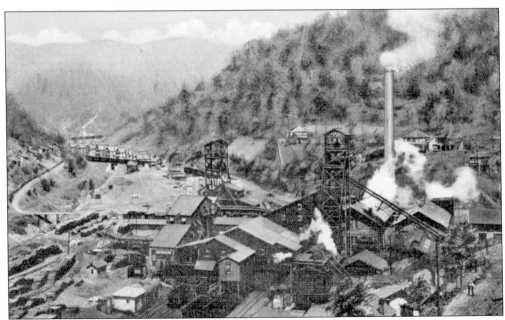

The Carswell Mine of the Koppers Coal Co. in McDowell County is seen above. Coalfield stores operated by Koppers were well known for their slogan "Make your coppers count at Koppers."

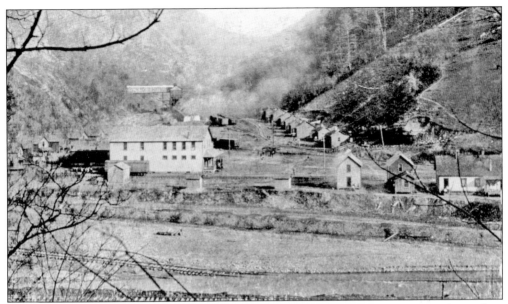

This card depicts the town of Carbondale, which is near Montgomery and home to the Carbon Coal Co.

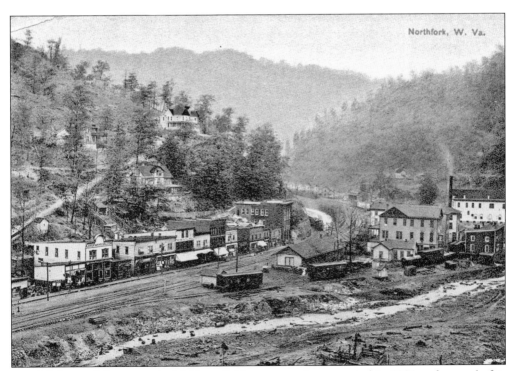

Northfork, a mining town in McDowell County, was incorporated in 1901 and named after the north fork of the Elkhorn River. It is located at the north fork's junction with the south fork. (For a view of a street scene in Northfork, see page 38.)

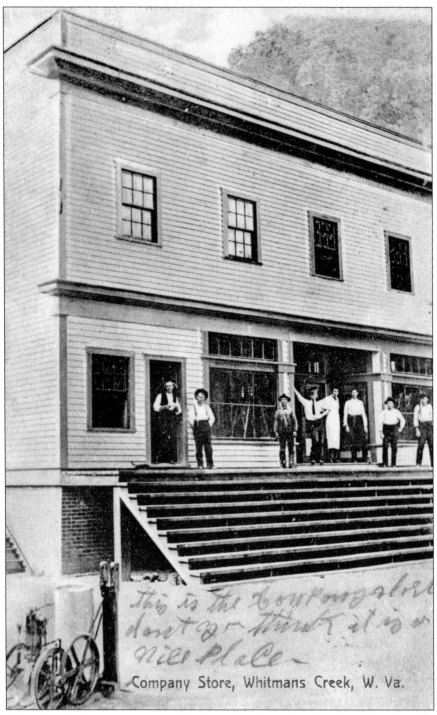

Company Store, Whitmans Creek, W. Va.

This 1912 postmarked card shows the Island Creek Coal Co. store at Whitmans Creek in Logan County. The sender wrote a penciled note across the front: "This is the company store. Don't you think it is a nice place (?)" Company-owned stores were a necessity in the coalfields, as generally there were not any other stores for miles around.

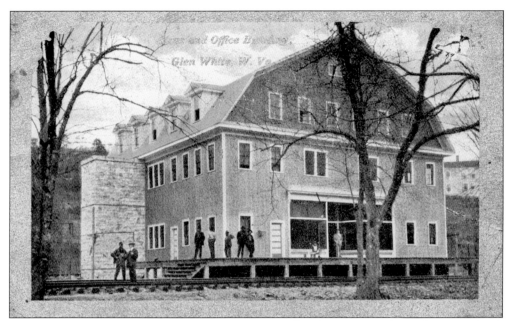

This is an undated view of the company store and office building at Glen White, a Raleigh County coal camp named for company president E.E. White. A native of England, White came to West Virginia in 1904 and operated a number of mines before selling them and retiring to Pennsylvania in 1925.

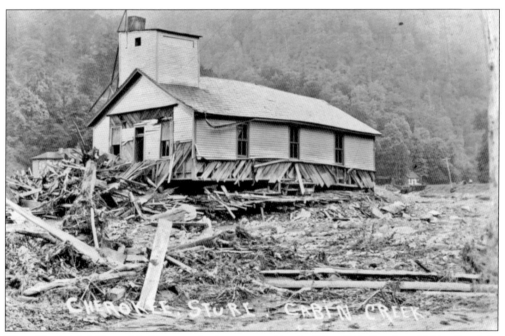

West Virginia's hills and hollows make it prone to floods. The 1916 flood on Cabin Creek in Kanawha County was one of the worst floods in many years. Postcards showing the damage were big sellers. This one shows the flood-damaged Cherokee Store at Cabin Creek. (For another card from the flood, see page 50.)

A company that made asbestos roof shingles mailed this postcard to promote its product: "Applied French Method on the Miners' Cottages of the New River Collieries Co., Gentry, W.Va."

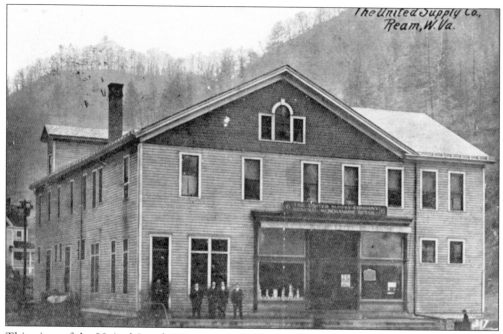

This view of the United Supply Co. store at Ream in McDowell County is postmarked 1919.

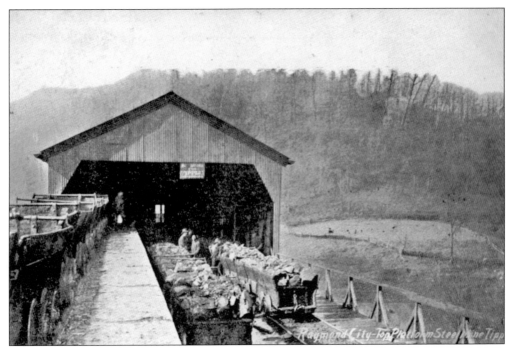

This is a view of the top platform of the steel tipple at the Raymond City mine in Putnam County. Postmarked 1908, the card has a stamped message on the back advertising "Raymond Coal—Holds Fire Over Night, Burns to White Ash."

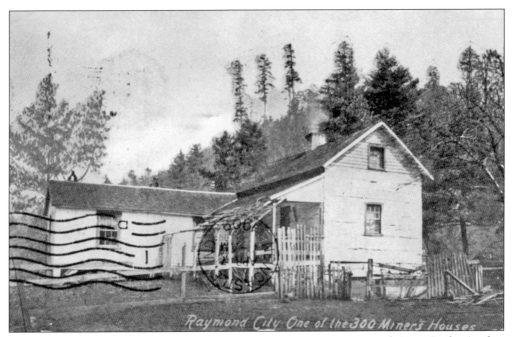

Here is a 1909 view of "One of the 300 Miners' Houses" at Raymond City. Coal mined at Raymond City was floated down the Kanawha River to Point Pleasant, then on down the Ohio to Cincinnati.

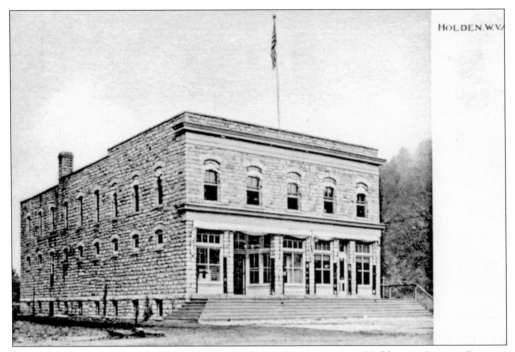

This is an undated view of the Island Creek Coal Co. store at Holden in Logan County. Founded in 1902, Island Creek Coal was earning more than $1 million a year in profits by 1916. Even during the grim years of the Great Depression it never missed paying a dividend on its stock.

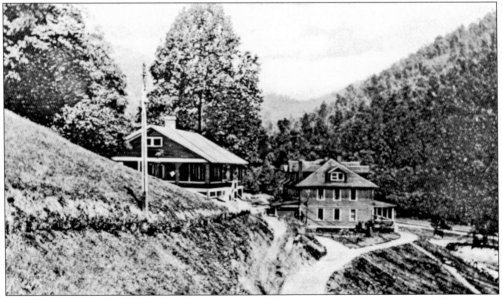

Here is an undated view of the Superintendent's Residence and Holden Inn at Holden.

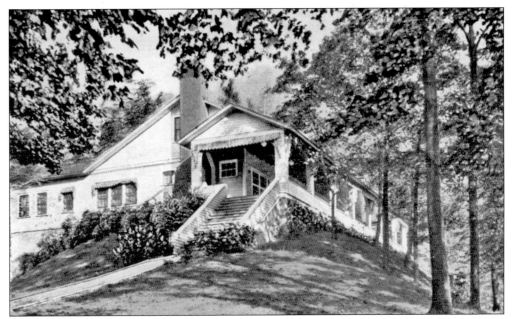

Mailed in 1949, this is a view of the Guest Bungalow at Holden. It was used by visiting Island Creek Coal officials and other VIPs. Holden was a model coal-mining community known for its tree-shaded streets named for company officials and for its well-kept houses.

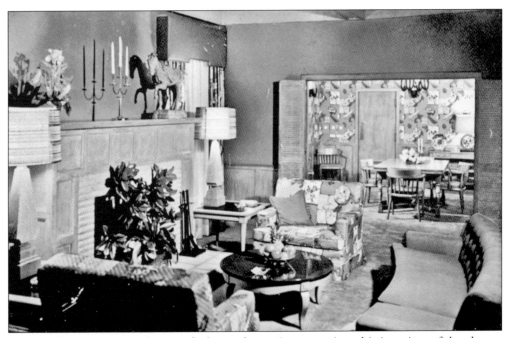

Looking like a page straight out of a home decorating magazine, this is a view of the elegant interior of the Guest Bungalow at Holden, c. 1950s.

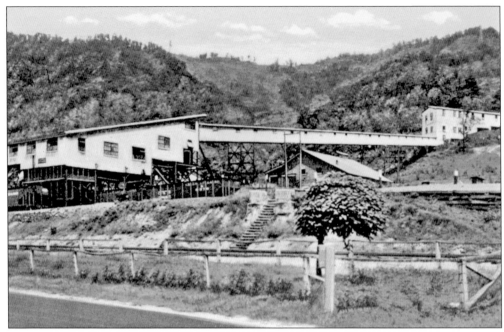

This undated card describes the scene as "A Modern Coal Operation in Logan County, near Logan, W.Va.," but otherwise offers no clue as to the mine's identity.

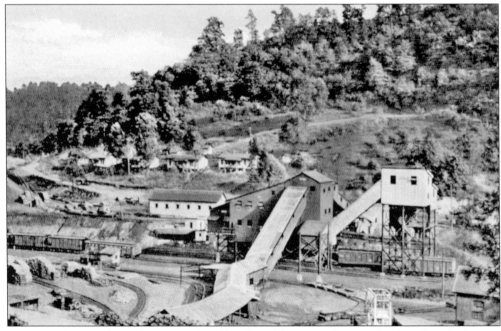

This "Modern Coal Tipple near Oak Hill and Beckley, W.Va." is not further identified.

# Two

# BIRD'S EYE VIEWS

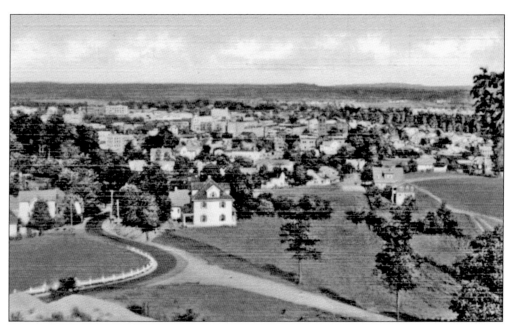

A perennial favorite of picture postcard makers was the bird's eye view, a panoramic look at a scene, generally a town, as seen from high above, as if by a bird in flight. Here is a bird's eye view of Beckley. It is undated but has a 1930s look. Beckley, chartered in 1838 and named for John Beckley, the first clerk of the United States Congress, grew and prospered with the coal industry.

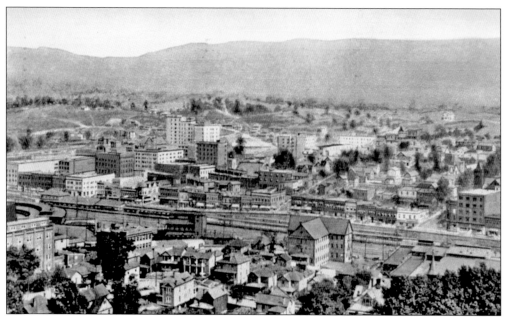

This card was postmarked 1939. Note how the railroad tracks dominate this bird's eye view of Bluefield, which played a pivotal role in the development of the coalfields and in the growth of the N&W Railway.

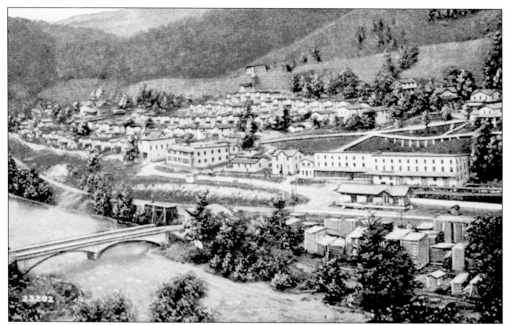

Although West Virginia is synonymous with coal, the state has also been home to a thriving timber industry. Shown here is the Pocahontas-County town of Cass, built in 1902 and named after Jacob Cass, an official of the timber company that started the community. Today, the same narrow-gauge locomotives and flatcars that once hauled logs down from Cheat Mountain now carry tourists up the mountain and back.

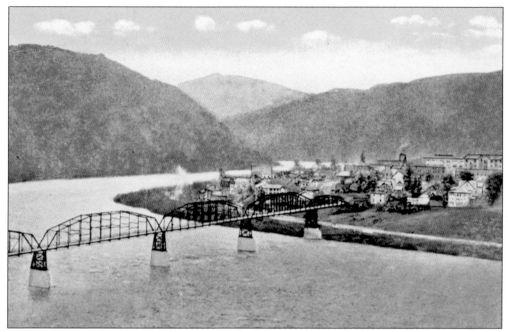

The C&O Railway brought jobs and explosive growth to Hinton, shown here in a card postmarked in 1924. In 1984 the downtown Hinton Historic District was placed on the National Register of Historic Places.

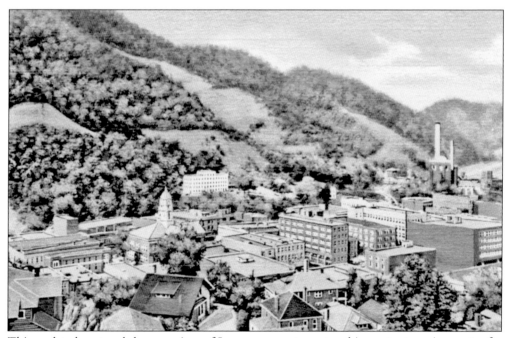

This undated postcard shows a view of Logan, a county seat and important service center for surrounding coal communities.

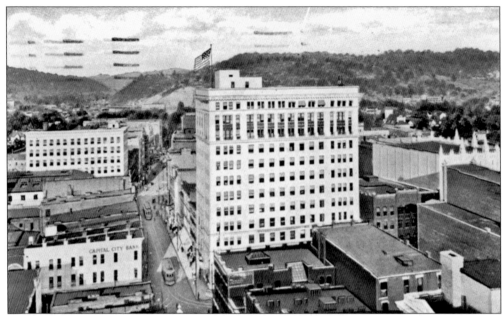

Postmarked in 1926, here is a view of Charleston, West Virginia's capital city. Established as Fort Lee, an outpost frontier during the 1780s, Charleston evolved into a center of commerce, culture, and government.

This is the C&O Railway Station in Charleston. The writer of this card, which was postmarked in 1931, wrote that he was "making speeches to striking miners every day and getting a big kick out of it. Last night seven state police, armed with pistols, clubs and a sub-machine gun, attended our meeting." The writer may have been poking fun, but, given the violence that sometimes flared in the coalfields, maybe he was not.

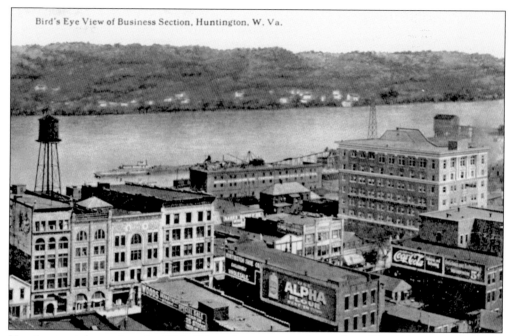

Bird's Eye View of Business Section, Huntington, W. Va.

Huntington is located on the Ohio River, just upstream from where West Virginia, Ohio, and Kentucky meet. Rail tycoon Collis P. Huntington founded the town in 1871 as the Western terminus of his C&O Railway. He chose well and the city prospered. Here, postmarked 1919, is a bird's eye view of the city's business section and some of the many wholesale houses that once supplied equipment to the region's mines and goods to its company stores.

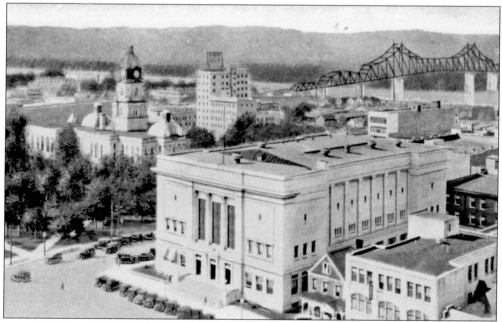

This undated bird's eye view shows Huntington City Hall, the Cabell County Courthouse, and the city's Ohio River Bridge.

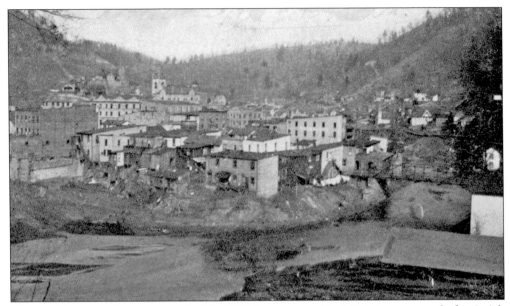

This Welch postcard was postmarked in 1909. Incorporated in 1894, it was named after Isaiah A. Welch, a captain in the Confederate Army.

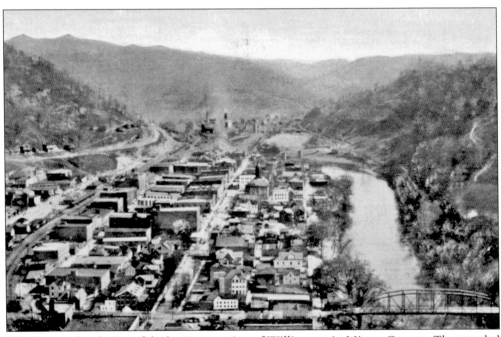

This is an undated view of the business section of Williamson in Mingo County. The wooded area at the right of the card is Kentucky. Williamson, incorporated in 1905, was named for Wallace J. Williamson, who once owned most of the land in the area.

*Three*

# STREET SCENES

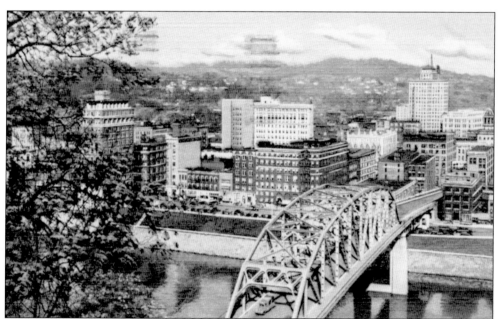

Like bird's eye views, street scene postcards of a town are also popular. This view shows Charleston's South Side Bridge and downtown business district. Constructed between 1936 and 1937 by the Depression-era Workers Progress Administration, the new bridge replaced an earlier span built in 1891.

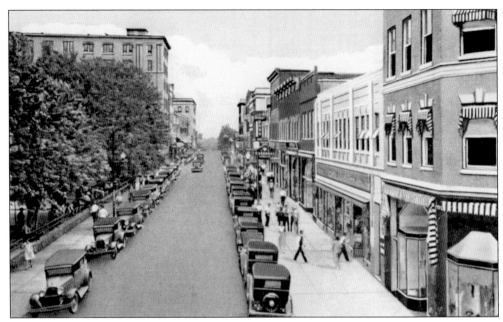

Here is a 1920s view of Beckley's busy Main Street. Mine families from miles around patronized Beckley's stores. Nearly all of the city's business leaders had direct ties to the region's coal companies.

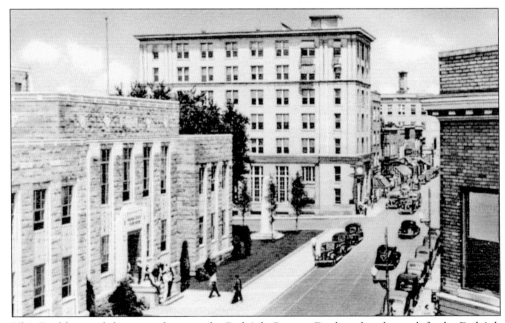

This Beckley card shows, at the rear, the Raleigh County Bank and, at lower left, the Raleigh County Courthouse. Grover C. Hedrick, twice mayor of Beckley, organized the bank in 1909 with a capital stock of $25,000.

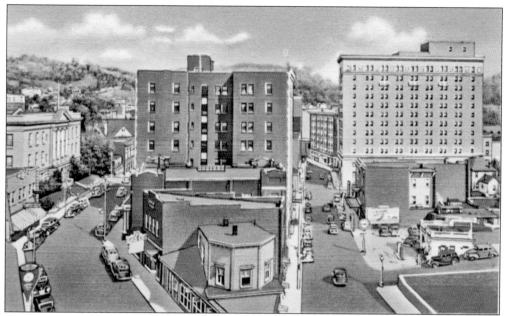

This is a 1930s view of the intersection of Bland and Federal Streets in Bluefield. Bluefield's mountain location makes for cool summers, hence the city's slogan: "Nature's Air Conditioned City." The Chamber of Commerce provides free lemonade when the temperature tops 90 degrees.

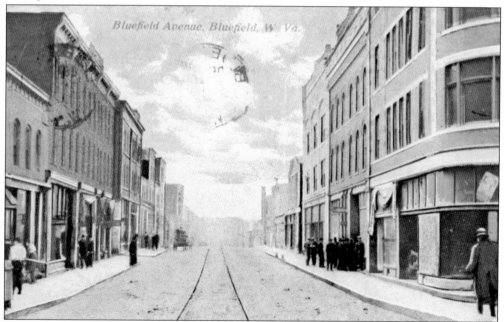

One of the leading cities of Southern West Virginia, Bluefield played a pivotal role in the development of the Pocahontas coalfield and in the growth of the N&W Railway. Although this early card offers little evidence of it, Bluefield Avenue was a busy place, as it was lined with mine supply houses. The rounded building at the right of the card housed Bluefield Supply, one of the largest. The building was demolished in 1988.

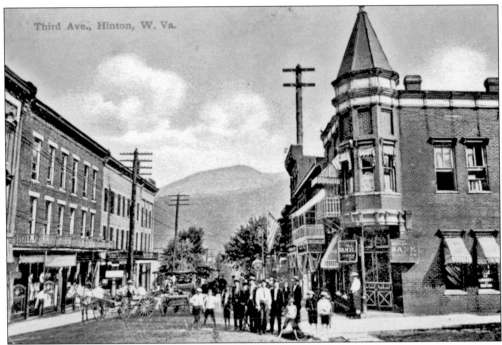

Only six families lived in Hinton in 1873, the year the C&O Railway was completed. By 1912, when this card was mailed, the population had grown to more than 6,000 and the downtown business district included a number of handsome buildings.

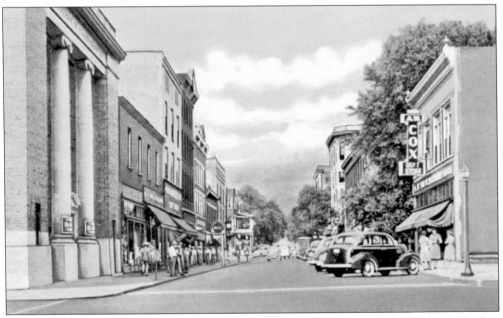

This vintage 1930s view of Hinton's Temple Street from 2nd Avenue shows the A.W. Cox Department Store and, on the opposite corner, the National Bank of Summers. Today, the old bank building is home to the Summers County Library, and the former department store houses the Summers County Visitors Center and Railway Museum.

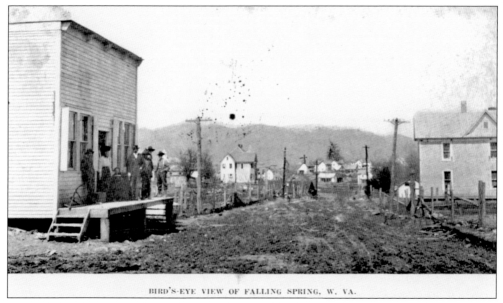

BIRD'S-EYE VIEW OF FALLING SPRING, W. VA.

The card maker labeled this a "Bird's Eye View of Falling Spring, W.Va." Unless the bird was flying really low, this is really a street scene of the Greenbrier County town, if you can call a broad expanse of mud a street.

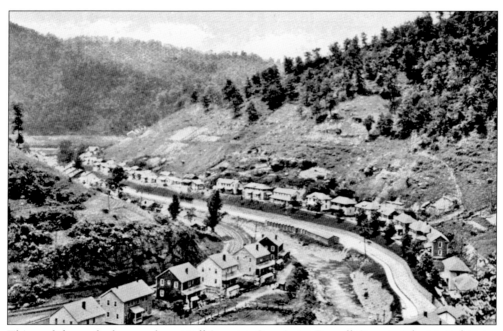

This card shows the houses along Wall Street at Gary in McDowell County. The United States Coal & Coke Co. tipple at Gary (not shown on this card) was said to be the world's largest before it was demolished in 1991.

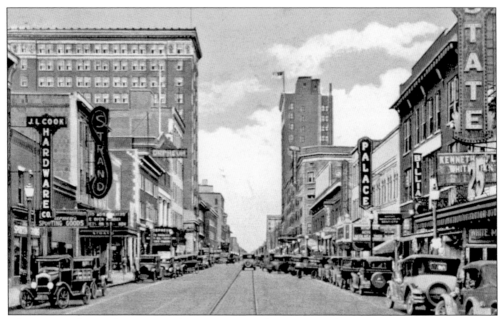

The postmark on this scene of Huntington's downtown 4th Avenue is illegible, but the automobiles shown would seem to date the card in the late 1920s or early 1930s. The card maker described this as a view "from 10th Street." It is really a view looking toward 10th Street.

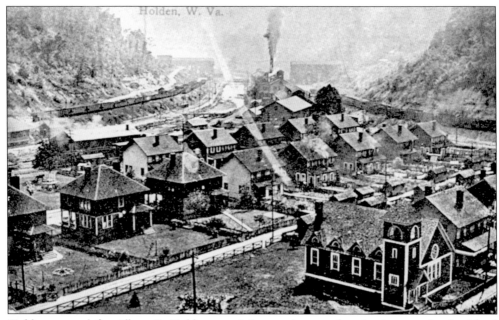

Holden, named for Albert F. Holden, a mining engineer and major investor in the Island Creek Coal Co., was a busy place, supplying area mines with workers, supplies, and equipment. The Logan County community was an example of welfare capitalism, an early 20th-century movement that sought to attract workers, and combat unionization by providing attractive homes and recreational facilities. This undated early card offers a good depiction of company houses.

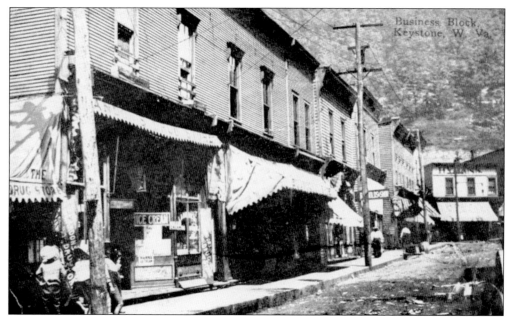

This card of Keystone in McDowell County, postmarked 1921, shows a number of businesses, including Landon's Drug Store. Look closely, and you will see that the store displays three signs notifying hungry passersby that it offers ice cream.

Logan played an important role in the Mine Wars of 1920–1921; it was the site of planning efforts by Sheriff Don Chaffin to counter the armed march of union miners and their supporters through the county. Here is an undated view of Stratton Street with a number of pedestrians, but not a car or truck in sight.

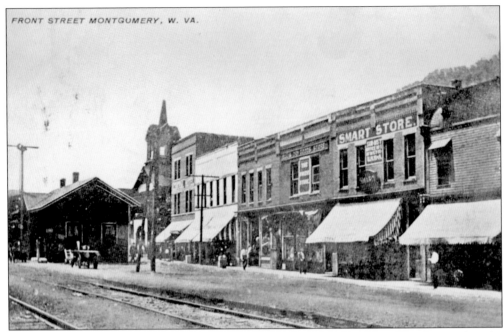

This card, postmarked 1908, shows Front Street in Montgomery, which straddles the Kanawha-Fayette County line. The tiny town was originally named Coal Valley when it was settled in the 1870s, a fitting name given the many mines nearby. When the community was incorporated in 1891, the name was changed to honor early settler James C. Montgomery.

This street scene of Northfork in McDowell County was postmarked 1909.

A penciled note on the back of this postcard of Princeton's Mercer Avenue is dated 1942; however, judging from the cars to be seen, the card actually shows a much earlier view. Just barely visible at the card's center is a distant streetcar. Incorporated in 1909, Princeton was the county seat of Mercer County. The town took its name from Princeton, New Jersey. In 1777, Gen. Hugh Mercer, the county's namesake, was killed there during the Revolutionary War.

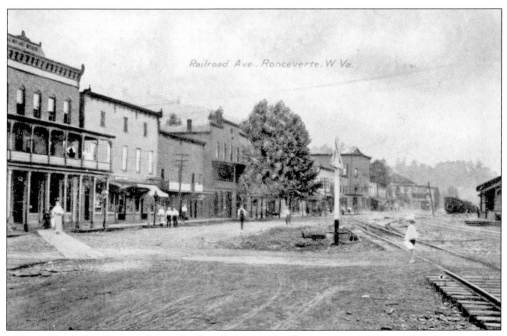

This early, undated view shows Railroad Avenue in Ronceverte in Greenbrier County. The community's name was derived from the French word for greenbrier. The area was home to some of the state's first settlers, with Thomas Edgar arriving *c.* 1780. His son built the first gristmill on the Greenbrier River.

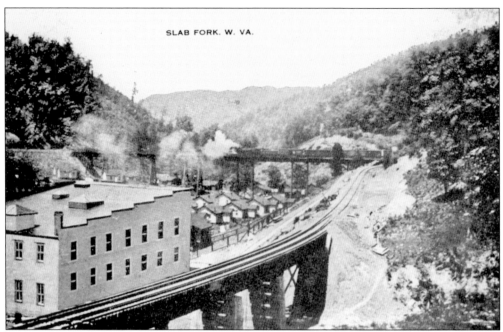

SLAB FORK. W. VA.

This card from Slab Fork was mailed in 1918. The Slab Fork Coal Co., incorporated in 1907, shipped the first railway car of coal from Raleigh County. The company's annual output grew from 250,000 tons in 1910 to 650,000 tons in 1956. Slab Fork closed its mines in 1982.

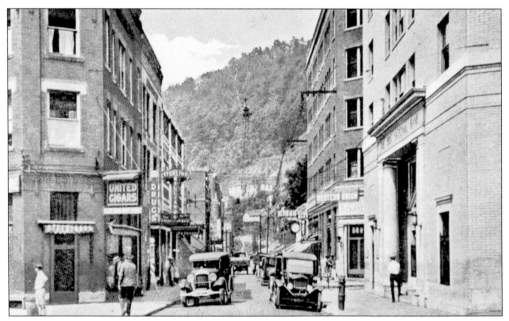

Welch, incorporated in 1894 and named for Isaiah A. Welch, a captain in the Confederate Army, became a busy distribution and service center for the coalfields of McDowell County. The county was so rich in coal that local legend said it had four acres of underground coal for every acre of its land surface.

This undated view of Welch looks north from Maple Avenue.

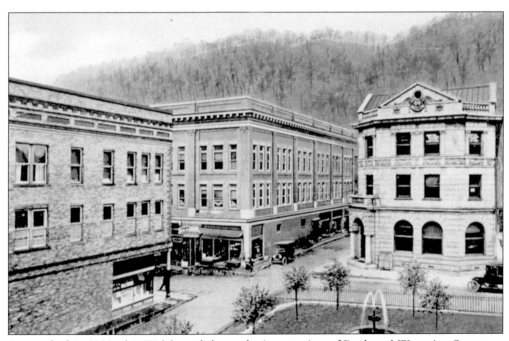

Postmarked in 1938, this Welch card shows the intersection of Bank and Wyoming Streets.

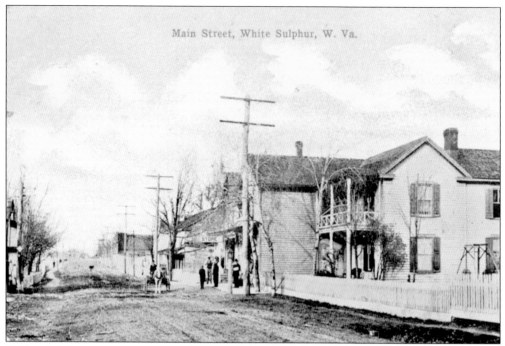

Main Street, White Sulphur, W. Va.

White Sulphur Springs in Greenbrier County was named by the earliest settlers after the springs they found in the area. This early, undated card shows what is identified as "Main Street," but is clearly nothing more than a dirt road.

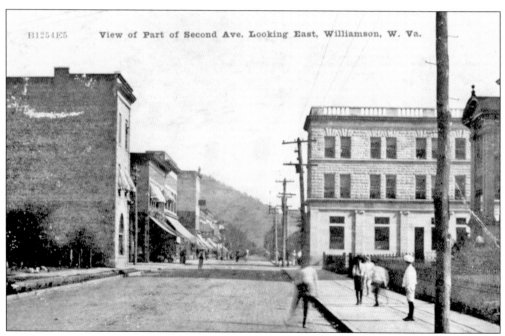

B1254E5 View of Part of Second Ave. Looking East, Williamson, W. Va.

Postmarked 1909, this card shows part of Williamson's 2nd Avenue, looking east. In the message on the back, the sender asks a girl to go with him to an upcoming ball game.

42

*Four*

# RAIL AND RIVER

COAL TRAIN ON CHESAPEAKE AND OHIO'S
PINEY CREEK BRANCH IN WEST VIRGINIA

The C&O Railway long held the distinction of the being the world's largest originator of bituminous coal. For years, the company's public relations department called the rail line the "Coal Bin of America." That title might have been more accurately applied to the rugged Southern West Virginia land where most of the coal was dug.

In 1871, when rail tycoon Collis P. Huntington established the new town of Huntington as the Western terminus of the C&O, work immediately started on a large railroad repair shop. The shop, shown here in a 1911 view, remains a major employer in Huntington.

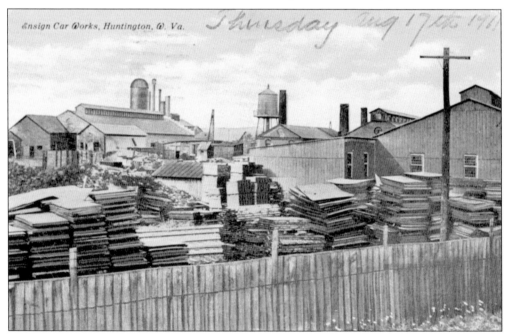

Collis P. Huntington and other backers organized the Ensign Car Works in Huntington in 1872. Named for Ely Ensign, who was in charge of its operation, the busy plant was soon turning out 4,000 rail cars a year. Shown here in a 1911 view, it was later acquired by American Car & Foundry (now ACF Industries Inc.).

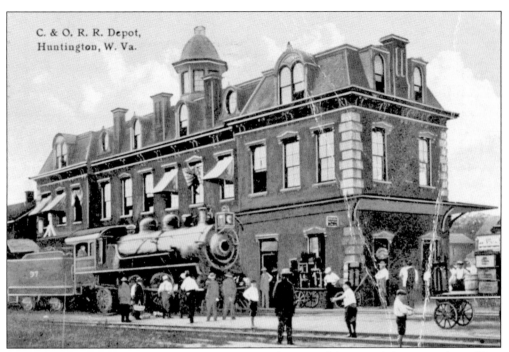

C. & O. R. R. Depot,
Huntington, W. Va.

Even though passenger traffic accounted for only a fraction of the C&O's business, the rail line nevertheless devoted considerable attention (and money) to its passenger trains and stations. Here, in a 1911 view, is the ornate structure that was its first Huntington depot.

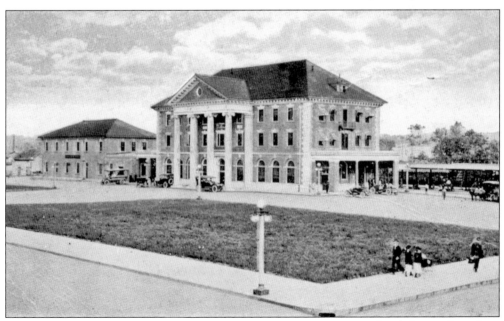

This card of the second C&O passenger station in Huntington is undated, but it does show the station before 1924, when a handsome statue of Collis P. Huntington was erected in the park-like setting at the front of the station. Today, the building houses offices for CSX Transportation.

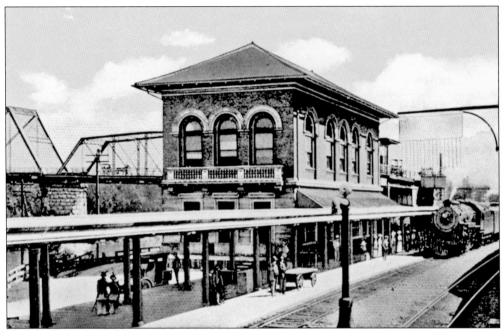

This card depicting the C&O passenger station in Charleston shows the station as it appeared in the years just before World War I. Today, the building houses business offices and a restaurant.

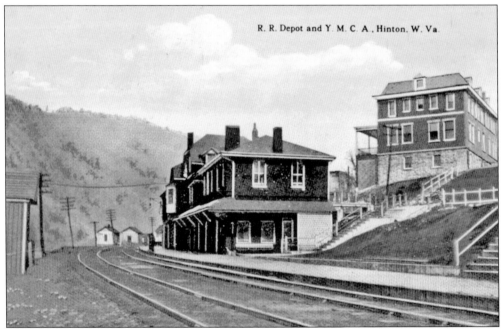

R. R. Depot and Y. M. C. A., Hinton, W. Va.

The C&O depot in Hinton was rebuilt in the early 1900s, after a fire destroyed the original structure. The old depot still serves Amtrak, whose Cardinal links Chicago and Washington D.C., via Southern West Virginia. The YMCA adjacent to the depot, one of the earliest Y's in the nation, was primarily built to provide overnight lodging and recreation for rail crews.

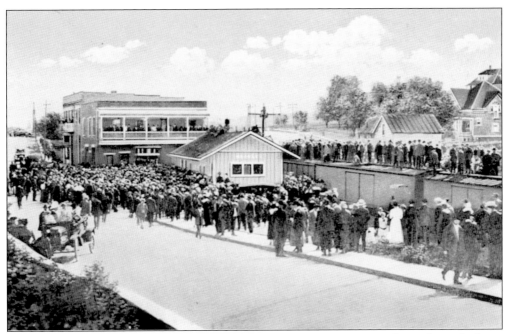

This is an early, but undated, view of the Union Depot in Beckley. Judging from the large crowd shown, a big event was in progress. Unfortunately, the card offers no information about the nature of the event.

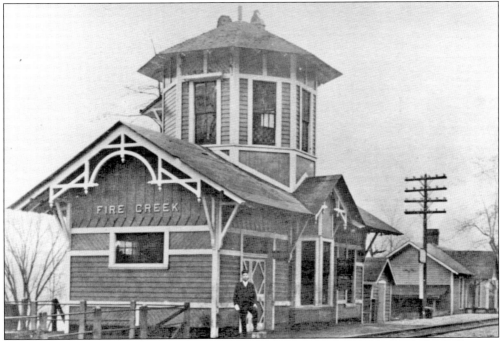

Built in 1894, this C&O depot at Fire Creek in Fayette County made efficient use of a limited amount of space by locating the passenger and freight station downstairs and the signal tower upstairs. (Courtesy the C&O Historical Society.)

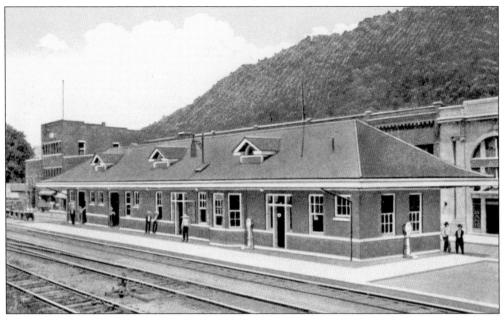

This is a view of the C&O station, a handsome brick structure, in Montgomery.

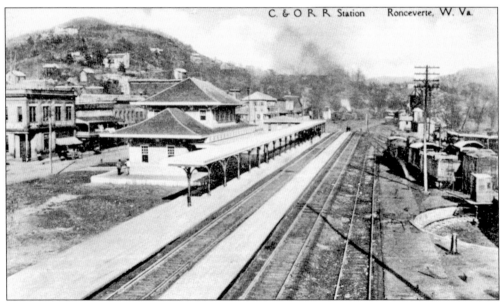

"Isn't this a good looking little depot?" asked the writer of the message on the back of this card, mailed in 1918 from Ronceverte in Greenbrier County. As the writer described, the C&O station was "built of a pretty gray brick, with cement walks all around."

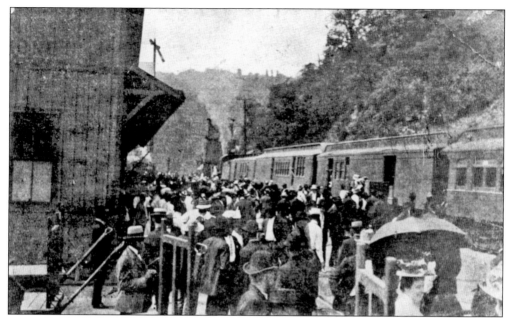

Located at a strategic junction on the C&O route map, the New River community of Thurmond attracted visitors by the score, as attested by this *c.* 1915 card showing the crowded platform at the passenger depot. Some came on business. Others came seeking a good time in the many saloons, dance halls, and houses of ill repute located in the adjacent community of Glen Jean. (Founder William Dabney Thurmond would not allow such unwholesome activity in his town.)

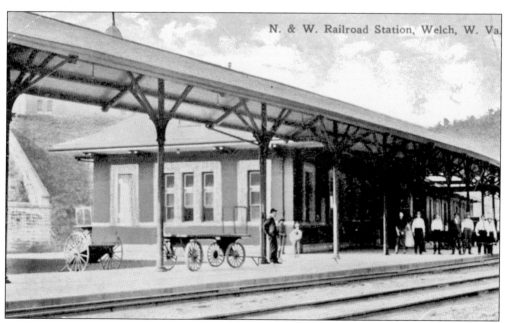

N. & W. Railroad Station, Welch, W. Va.

Like the C&O, the Norfolk & Western also devoted considerable attention and resources to its passenger business, operating a number of trains and erecting handsome stations, such as this one at Welch, shown in a card postmarked 1913.

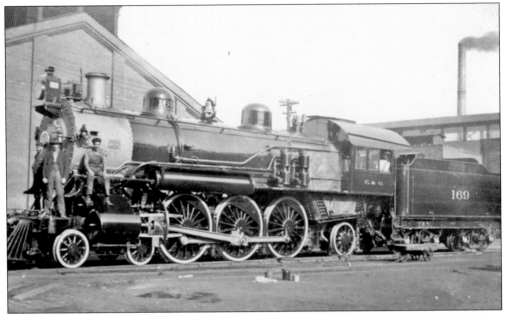

A handwritten note on the back of this card showing C&O locomotive 169 indicates it was photographed at Hinton, but offers no clues as to who the men in the photo might have been or when it was taken.

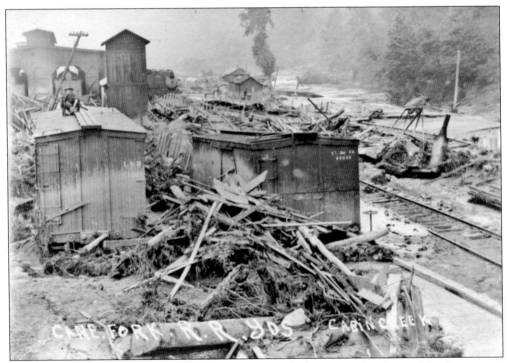

The 1916 flood at Cabin Creek, a popular subject with the postcard makers of the day, turned many of the railroad cars there into little more than scrap lumber. (For another postcard showing the flood, see page 19.)

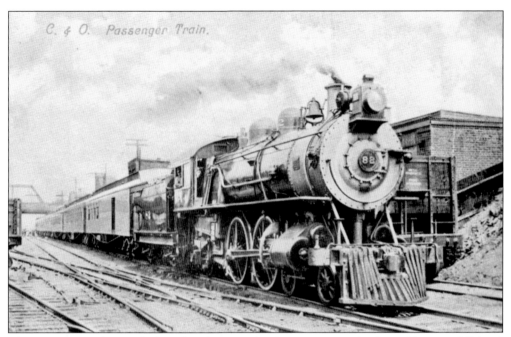

The caption on this card identifies this as a C&O passenger train, but offers no additional information. The locomotive carries the number 82.

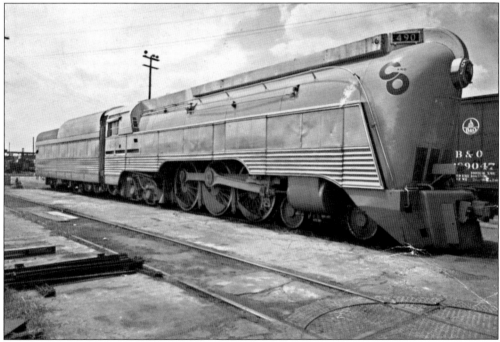

Before succumbing to the lure of diesel power, the C&O tried streamlining old steam locomotives. Built in 1926 as a Hudson-type, No. 490 was streamlined in 1946 and served on several routes before being retired in the mid–1950s. Today, it is in the collection of the Baltimore & Ohio Railroad Museum in Baltimore, Maryland.

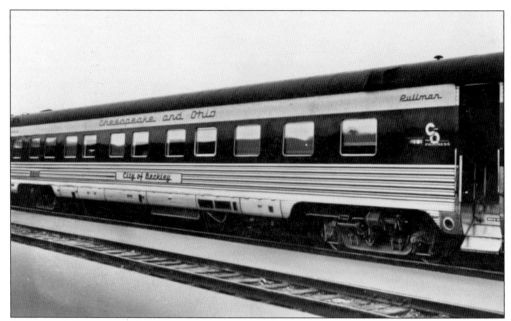

In the early 1950s, the C&O put a new fleet of streamlined passenger coaches into service, including this one named *City of Beckley*. The printed information on the back of this card advertises that the coach "has all private rooms equipped with most modern accommodations."

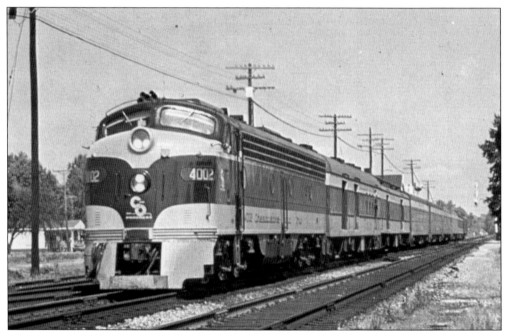

This 1963 view shows an E08 diesel unit at the head of the eastbound George Washington. The C&O's premier passenger train, *The George* made its first run in 1932 and continued operating for nearly 30 years, until Amtrak was formed in 1971. Amtrak briefly used the famed name, but soon consigned it to railroad history.

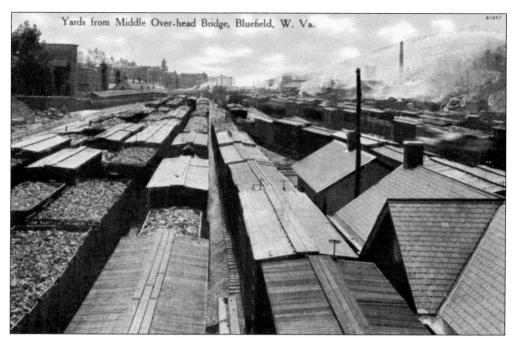

Yards from Middle Over-head Bridge, Bluefield, W. Va.

In a 1926 marketing brochure, the Norfolk & Western Railway, which linked Norfolk, Virginia, with Columbus and Cincinnati, Ohio, boasted that it had 2,241 miles of main line track and 1,568 miles of sidings and yard tracks. This view of the busy N&W yards in Bluefield provides a good example of the latter.

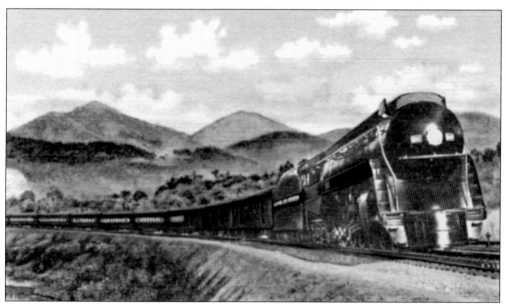

Debuting in 1926, N&W's *Pocahontas* carried untold thousands of travelers through the coalfields of Southern West Virginia. By the early 1950s, however, rail ridership everywhere was dropping and by the 1970s, passenger service along the N&W route was a memory. Shown here is the Pocahontas near the end of its career, with a streamlined, steam-powered Class J locomotive doing the honors.

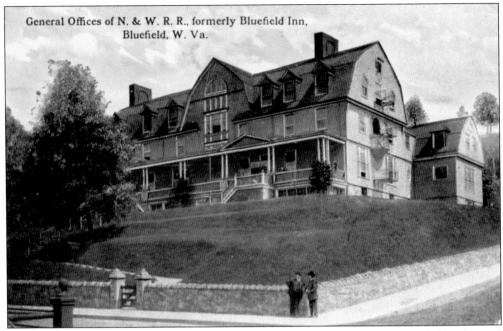

General Offices of N. & W. R. R., formerly Bluefield Inn,
Bluefield, W. Va.

This is a view of the N&W General Offices, formerly the Bluefield Inn in Bluefield. The card is postmarked 1913.

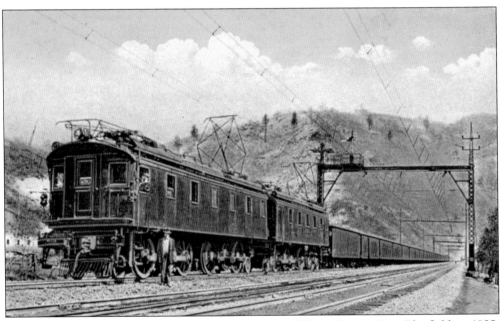

This is the "Largest Electric Freight Motor in the World" on the N&W at Bluefield, *c.* 1925. The N&W turned to electric power, rather than steam, in an effort to better cope with the steep grades in the coalfields and end the problem of smoke in the many tunnels along the line. Power for the electrified locomotives came from a powerful generating plant at Bluestone.

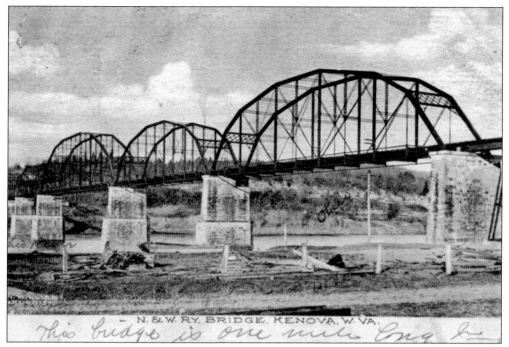

The N&W bridge across the Ohio River has long been a landmark at Kenova in Wayne County, just downstream from Huntington. This view of the span was postmarked 1907.

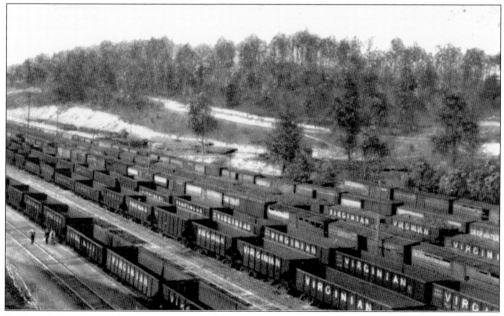

Railroad historian Thomas W. Dixon has described the Virginian Railway as a huge "coal conveyor," designed to shuttle coal from the mines of West Virginia to the coal piers at Newport News, Virginia. This view of the Virginian yards at Princeton gives a good idea of the rolling stock required for that task. The Virginian was absorbed by the N&W (now Norfolk Southern) in 1959.

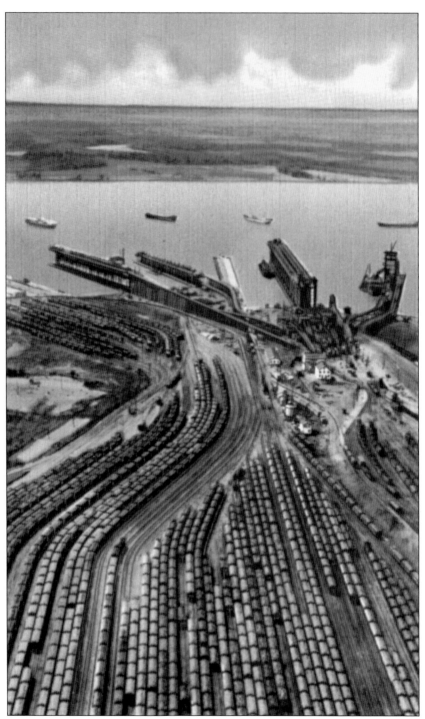

Although this is a collection of Southern West Virginia scenes, it seems only fitting that the out-of-state postcards above and at upper right also be included, as they show where much of the region's coal was bound for when it was hauled away by rail. Shown above are N&W's giant storage yard and piers at Lambert Point in Norfolk, Virginia.

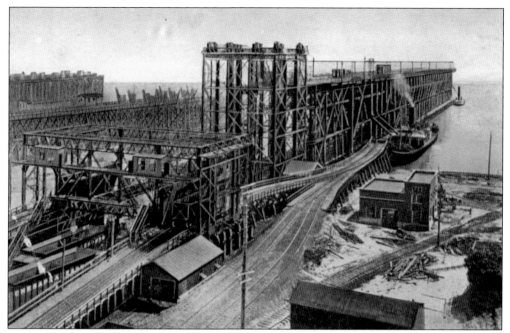

Here is an undated view of the C&O's coal pier No. 9 at Newport News, Virginia. Originally, the C&O, N&W, and Virginian sent much of their coal to the northeastern United States by ship, since it was cheaper than sending it by rail the whole way. But after World War II, exporting coal to foreign buyers became a large portion of this business.

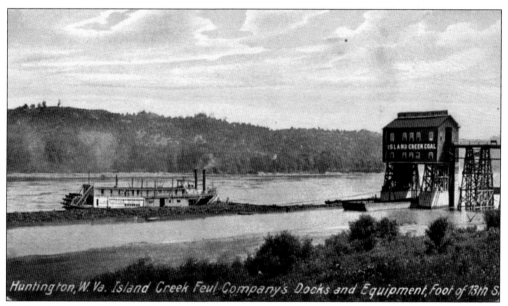

For decades, this coal tipple, built on the Ohio River at Huntington in 1906, was the last stop for long trainloads of coal being hauled westward by the C&O from the Island Creek Coal Company's mines in Logan and Mingo Counties in Southern West Virginia. (Note the card caption's misspelling of "Fuel" in the company's original name.) The old tipple was demolished long ago. Today, only the concrete piers remain.

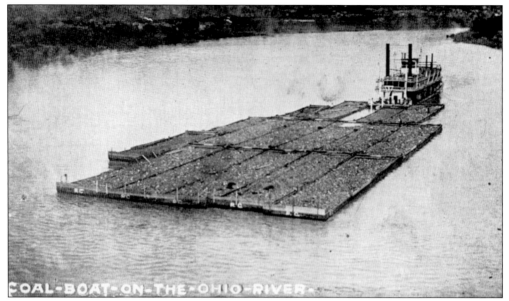

This postcard was mailed in 1909, when steam was king on the Ohio River. Diesel power drove the steamboat from the river for the same reason it replaced the chugging steam locomotive on the nation's railroads—it was cheaper and more efficient. One thing has not changed since 1909, however. Coal still accounts for a huge share of the barge traffic that travels the Ohio and its tributaries.

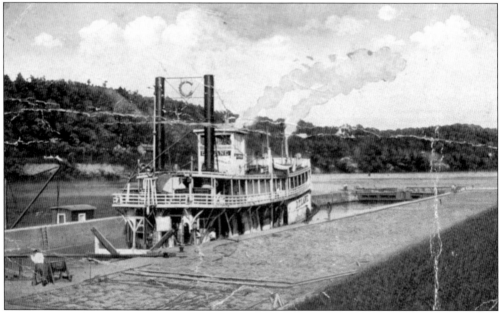

Equally important to the coming of the railroads in the development of the coal industry in the Kanawha Valley were navigational improvements that made it possible for mines to ship coal down the Kanawha to the Ohio. Here, in an undated vintage view, a steamboat passes through Lock No. 6 on the Kanawha near Charleston. The giant letter "C" hanging between the two smokestacks marks the boat as belonging to Campbell's Creek Coal Co.

## *Five*

# CHURCHES AND SCHOOLS

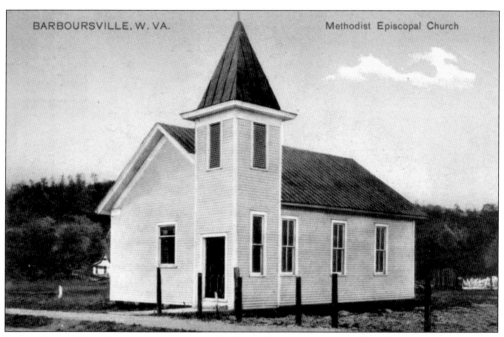

In Southern West Virginia, churches and schools functioned as unofficial community centers, playing central roles in the lives of both large and small towns. This chapter offers cards showing a representative sample, from small country chapels to ornate city churches, and from simple, one-room schools to busy high schools. Shown here, in a card postmarked 1910, is the Methodist Episcopal church at Barboursville in Cabell County.

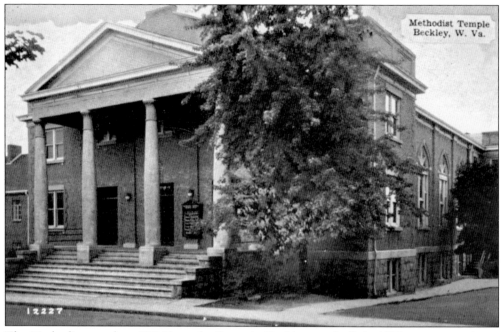

The Methodist temple at 500 Kanawha Street in Beckley was built in 1928 at a reported cost of $100,000. This card is undated, but appears to date from the 1940s.

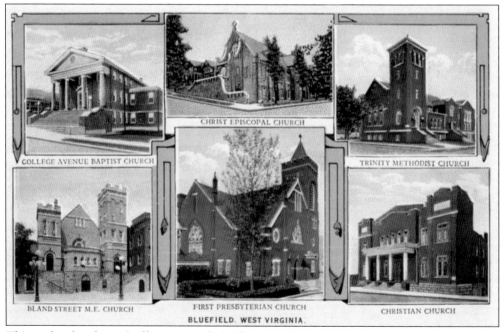

This undated early card offers views of a half-dozen Bluefield churches.

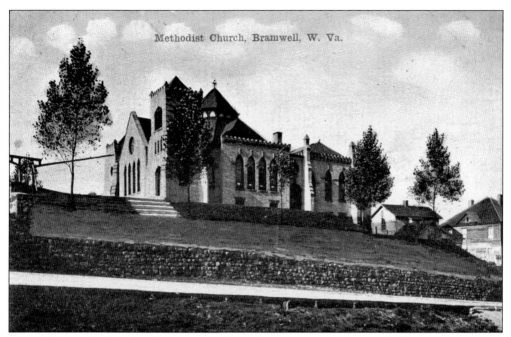

Here is the Methodist church in Bramwell, as shown on a card postmarked 1911.

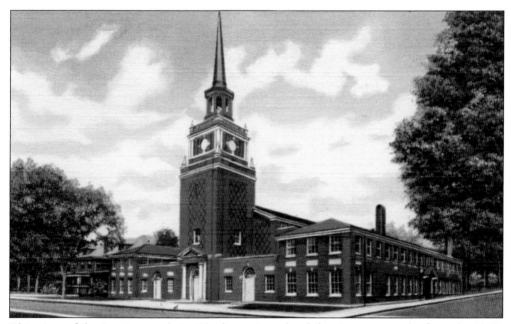

This view of the Baptist temple in Charleston is undated, but it appears to be from the 1940s or 1950s.

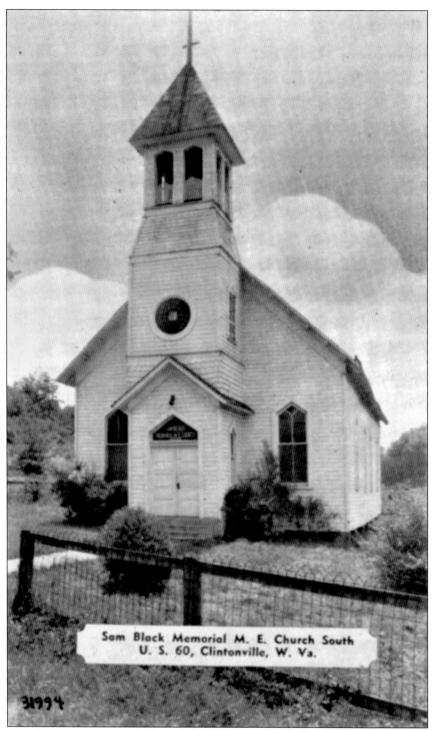

Sam Black Memorial M. E. Church South
U. S. 60, Clintonville, W. Va.

31994

Sam Black (1813–1899) is remembered in the name of the Sam Black Memorial Methodist Church at Clintonville in Greenbrier County. Black was a Methodist circuit rider for almost 50 years.

Here is the Methodist church at the corner of Mansion and Vine Streets in Hamlin in Lincoln County.

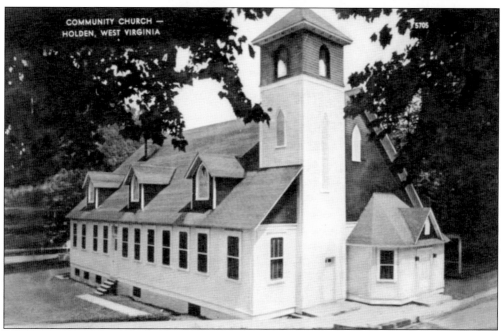

This undated card shows the Community Church in Holden.

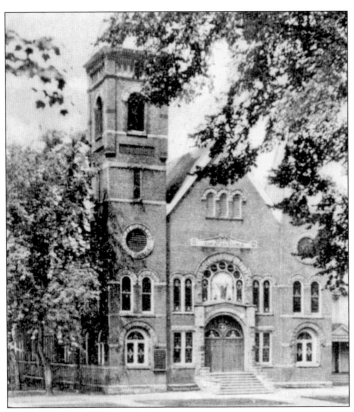

Central Christian Church in Huntington is one of the city's oldest. Organized in 1891, the congregation built this handsome church building in 1895.

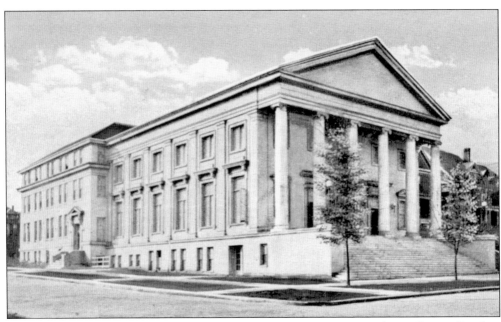

In Huntington's earliest years, the city's Baptists met upstairs over a saloon. Eventually, they built a church. Later, in 1919, they erected this building at 5th Avenue and 12th Street. It is the Fifth Avenue Baptist Church (not "First Baptist," as printed on this undated card).

The Central Baptist Church in Hinton was erected in 1923.

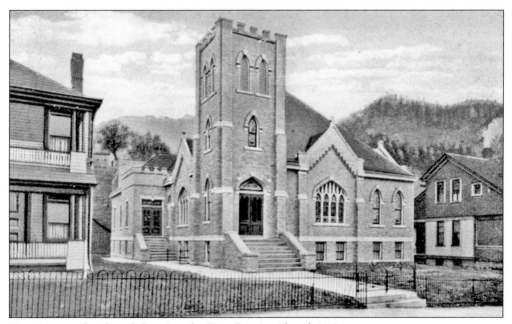

Here is an undated card showing the First Baptist Church in Logan.

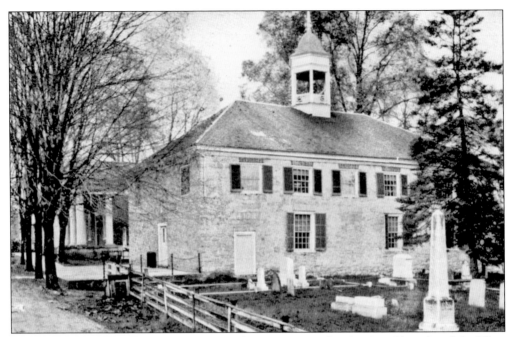

Lewisburg's historic Old Stone Church, built in 1796, is said to be the oldest church building in continuous use west of the Alleghenies. Col. John Stuart and his wife, Agatha, donated the land for the church.

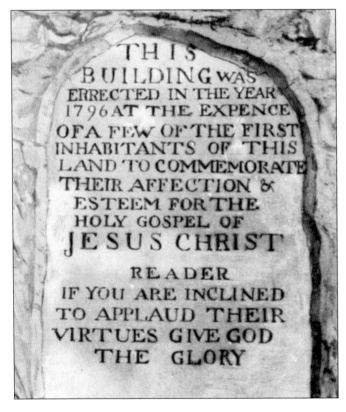

THIS BUILDING WAS ERRECTED IN THE YEAR 1796 AT THE EXPENCE OF A FEW OF THE FIRST INHABITANTS OF THIS LAND TO COMMEMORATE THEIR AFFECTION & ESTEEM FOR THE HOLY GOSPEL OF JESUS CHRIST

READER IF YOU ARE INCLINED TO APPLAUD THEIR VIRTUES GIVE GOD THE GLORY

This inscription over the door of the Old Stone Church is said to have been made by Colonel Stuart.

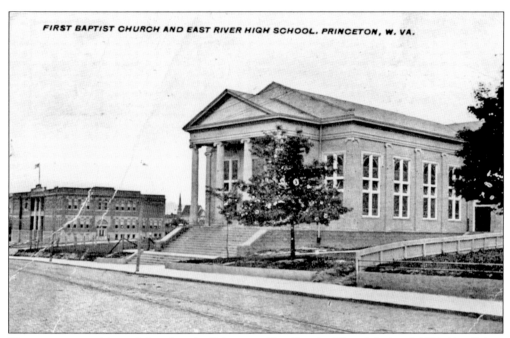

The message on this card showing the Princeton First Baptist Church is dated 1916. East River High School is visible at the left of the card.

The First Methodist Church in Welch is shown on this card, with a handwritten message dated 1950.

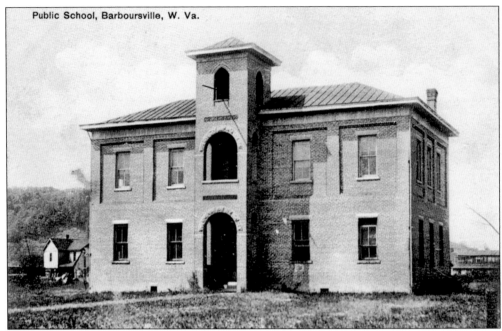

Public School, Barboursville, W. Va.

Originally chartered by Virginia in 1813 and named after Virginia governor James Barbour (1812–1814), Barboursville in Cabell County was re-chartered by the West Virginia Legislature in 1867. In its early years, the village boasted a sawmill, tanner, harness maker, and this handsome school, shown on a card mailed in 1909.

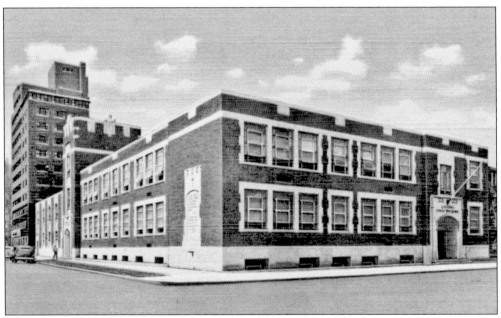

The Sisters of Saint Joseph operated a Catholic school in Charleston from 1867 to 1895. It reopened as Sacred Heart in 1903. Today's Charleston Catholic High School, an outgrowth of Sacred Heart, was founded in 1927. It is shown here in an undated view.

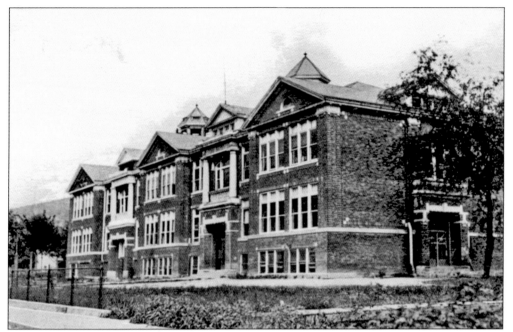

Timber, coal, oil, gas, and chemicals contributed to the growth of Clendenin in Kanawha County. In 1920, Union Carbide opened a Clendenin plant that became the birthplace of the nation's petrochemical industry. This prosperity provided the money needed to construct this impressive building for Clendenin High School, shown here in an undated early view.

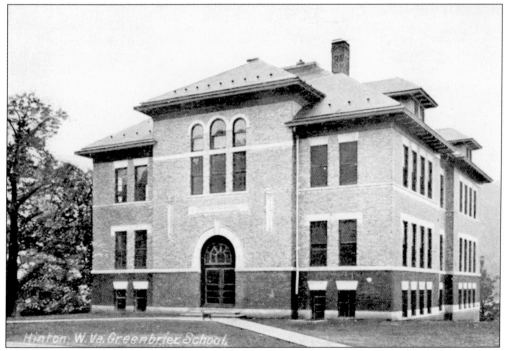

A penciled message on the back of this card, showing the Greenbrier School in Hinton, dates from 1911.

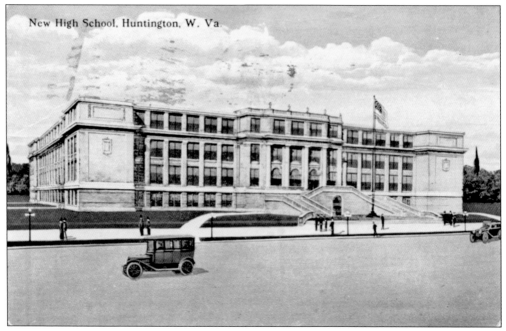

New High School, Huntington, W. Va.

Huntington High School—designed by architect Verus T. Ritter—welcomed its first students on September 4, 1916, and continued in use until 1996, when it was merged with Huntington East High School into a new consolidated school. Today, the old building is a community center. The designer of this card, which is postmarked 1917, used a bit of artistic license to show the street in front of the school as about twice its real width.

This view of Logan High School is undated.

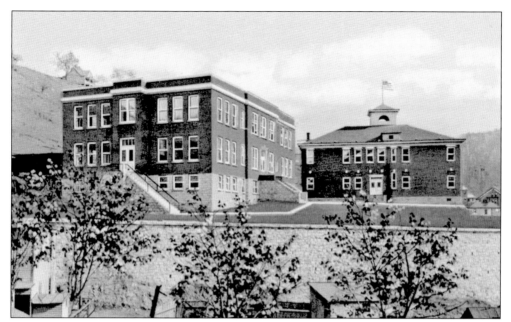

Logan Junior High is shown in this undated view.

This is an undated view of Oakland Graded School at Longacre in Fayette County. The card's caption describes it as a "First Class Standard School."

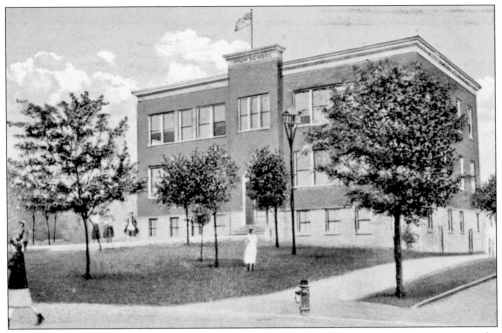

In 1893, the C&O completed a connecting link from Thurmond to Mount Hope, on the Southern edge of Fayette County, providing a ready means of getting the region's coal to market. Mount Hope had grown to a population of 12,000 people when, in 1910, a disastrous fire burned much of the town. The fire destroyed 40 business buildings and 150 homes. The town quickly rebuilt. Shown here is the town's "New High School," postmarked 1922.

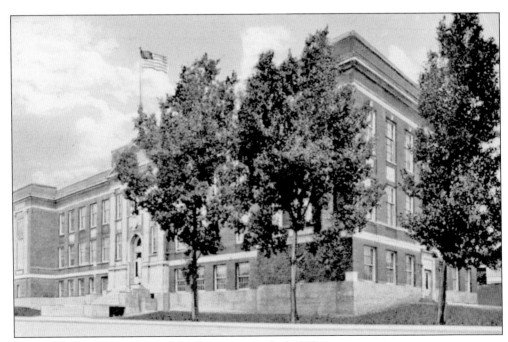

This card of Princeton High School was postmarked 1932.

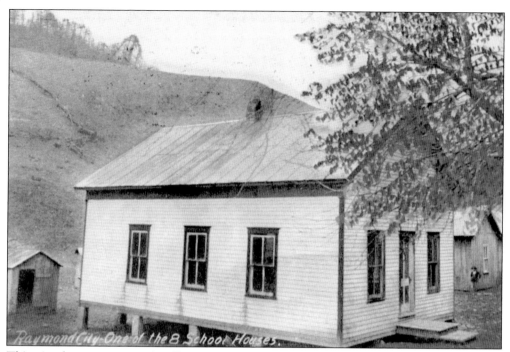

This simple, one-room schoolhouse was located at Raymond City in Putnam County. Hundreds of similar structures dotted the landscape of Southern West Virginia in an era before school buses shuttled youngsters to consolidated schools.

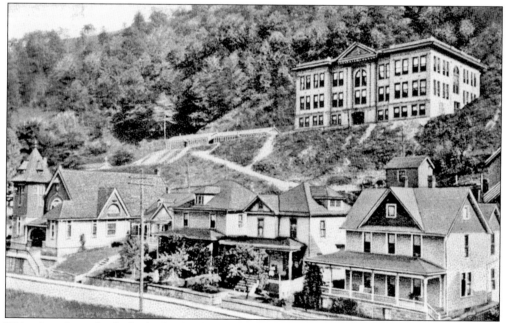

This view shows both the high school and Methodist Episcopal church in Welch.

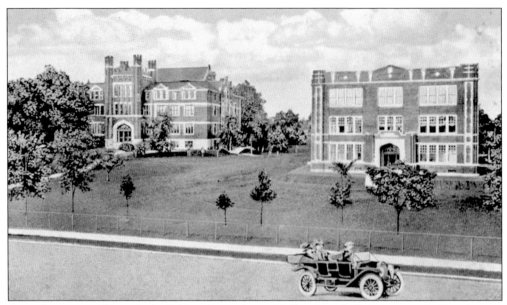

Over the years, Old Main (at left) and Northcott Hall at Marshall University in Huntington welcomed thousands of students from Southern West Virginia. Northcott Hall, built in 1916, was demolished to make way for the construction of the school's John Deaver Drinko Library.

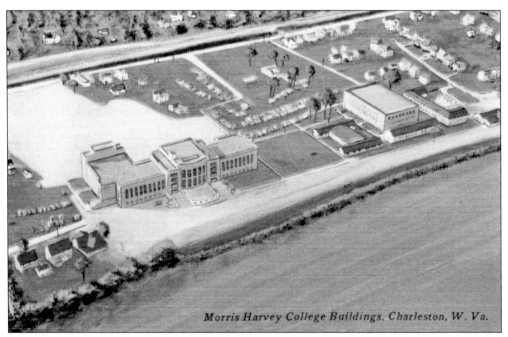

*Morris Harvey College Buildings, Charleston, W. Va.*

The campus of the University of Charleston, formerly Morris Harvey College, lies along the Kanawha River opposite the state capitol in Charleston. The large building facing the river is Riggleman Hall, named in honor of Leonard Riggleman, the school president who, in 1935, engineered the school's move from Barboursville to the capital city. This aerial view is undated but has a 1950s look to it.

# *Six*

# BANKS AND HOTELS

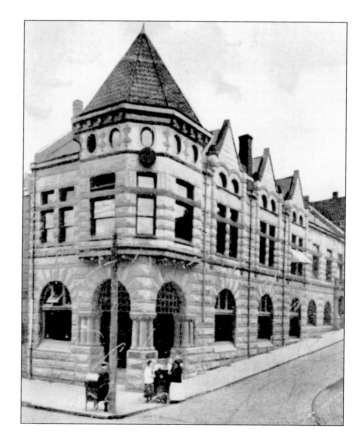

Built in 1895, the sandstone building at Princeton Avenue and Bland Street in Bluefield originally housed the People's Bank of Bluefield, but by 1913, when this postcard was mailed, it had been sold to the First National Bank. Later, the building became home to Pedigo's Store and White's Pharmacy.

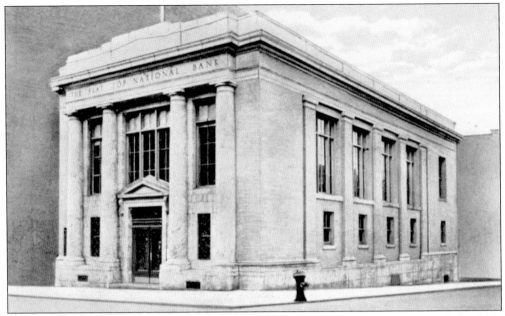

Here is an undated view of what the card called the "new" Flat Top National Bank in Bluefield. The rich Pocahontas Coalfields were originally known as the Flat Top Fields, hence the bank's name.

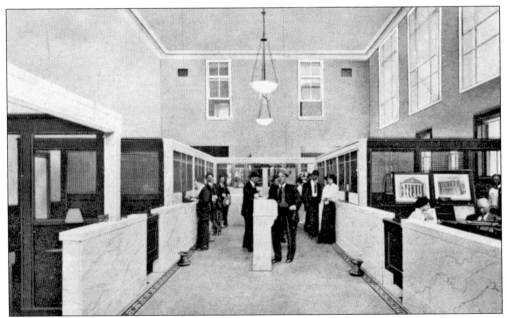

Here is an interior view of the Flat Top National Bank. Note the strategically placed spittoons on the floor.

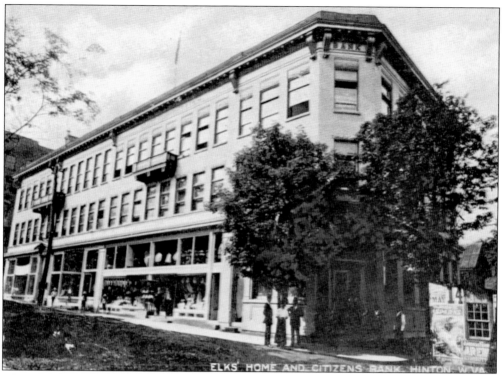

This building, which housed the Elks Home and Citizens Bank, was erected *c.* 1906 and was a relatively new addition to the Hinton scene when this card was mailed in 1907.

This view of the First National Bank of Logan is undated, but the car at lower left would suggest the late 1920s or early 1930s.

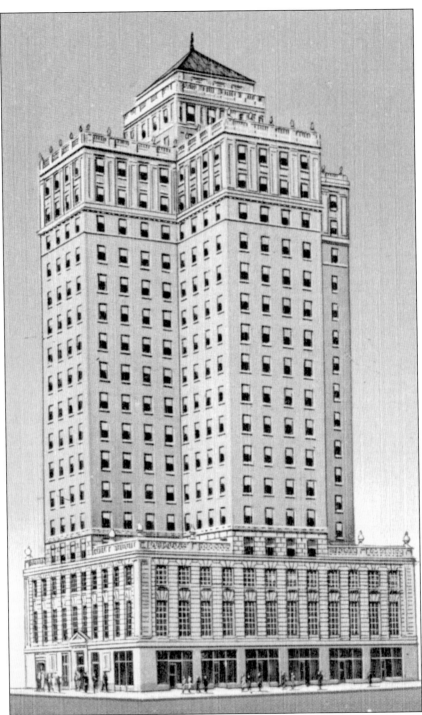

This imposing building at the corner of Lee and Capitol Streets in Charleston was home to the Kanawha Valley Bank from 1929 to 1976, when it moved to new, modern quarters. This undated card boasts that the building was "the largest in the United States for a city of Charleston's size."

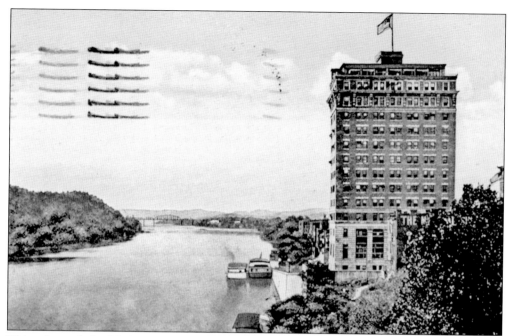

This view of the Union Trust Co. Building on the Kanawha River in Charleston was postmarked 1927. Perched right on the river's edge, the building offers a commanding view.

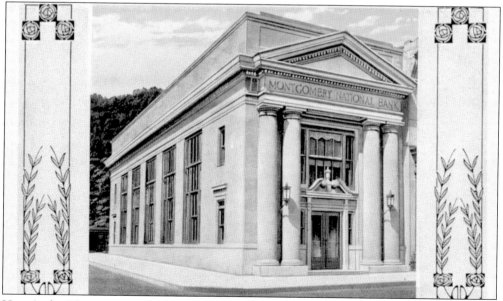

Here is the Montgomery National Bank. The fancy decorative devices at the left and right were common on early postcards.

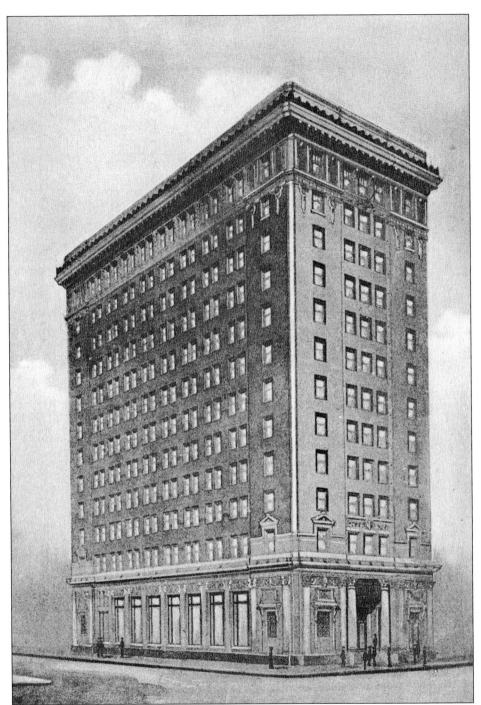

In 1912, the First National Bank began construction of what would become one of Huntington's best-known landmarks, a 12-story building designed by architect Verus T. Ritter. This card dates from before 1925, when an addition was constructed at the rear. In addition to the bank, the building, on the corner of Fourth Avenue and Tenth Street, provided offices for some of the city's leading doctors, lawyers, and businessmen.

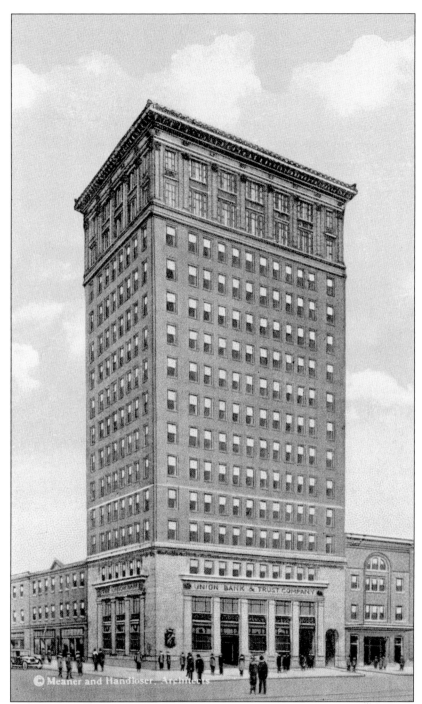

The Union Bank and Trust Co. originally occupied a small frame structure on the northeast corner of 4th Avenue and 9th Street in Huntington. But in 1924, the bank built this handsome building. In 1943, the bank went into receivership and the building—the tallest in Cabell County and among the tallest in the state—was renamed the West Virginia Building. Today, it houses offices and apartments.

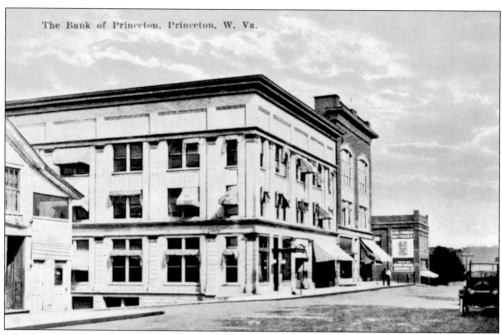

This early, undated chard shows the Bank of Princeton.

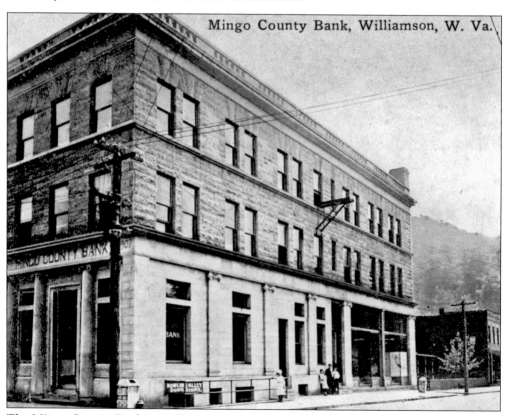

The Mingo County Bank in Williamson is shown on this card, dated 1910.

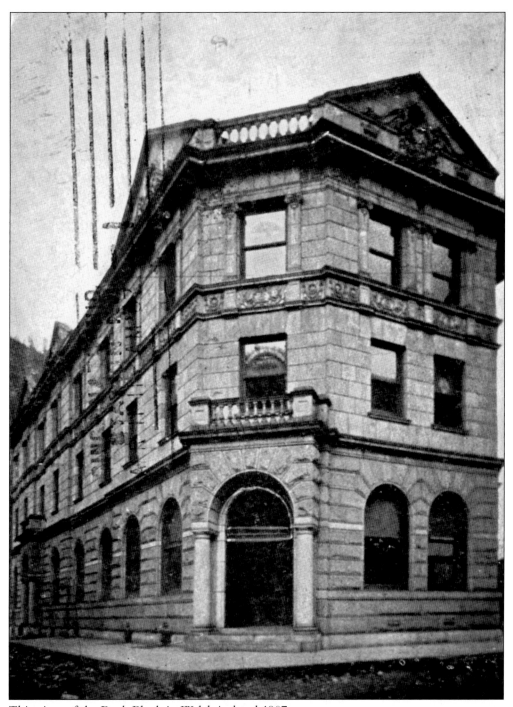

This view of the Bank Block in Welch is dated 1907.

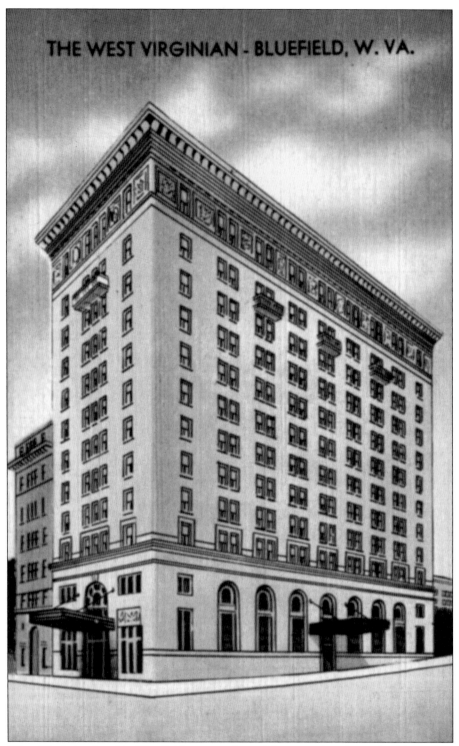

THE WEST VIRGINIAN - BLUEFIELD, W. VA.

The West Virginian hotel in Bluefield was another of the many handsome buildings designed by Bluefield architect Alexander Blount Mahood. This view is postmarked 1944.

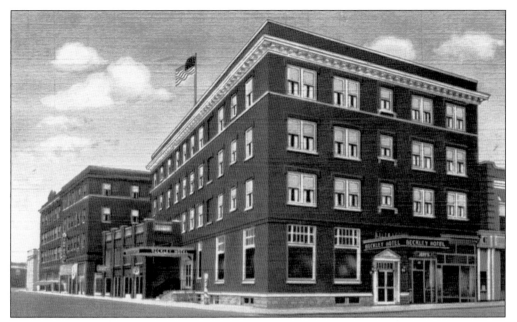

The Beckley Hotel on the corner of Main and Kanawha Streets in Beckley was a popular stop for many travelers.

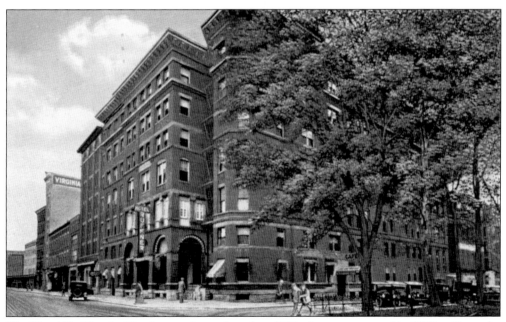

The Hotel Ruffner in Charleston, shown here in a 1936 view, was erected in 1886 at Kanawha and Dickinson Streets on the site of the former Hale House, which had burned the year before. The Ruffner was demolished in 1970 as part of the city's urban renewal program.

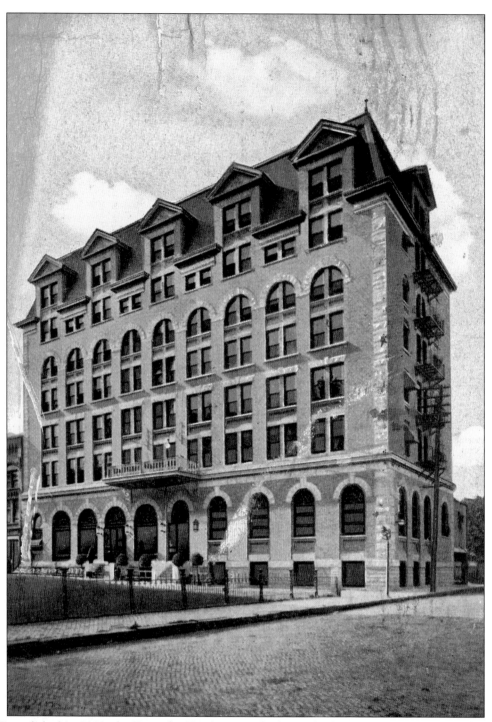

Demolished in 2003, the Kanawha Hotel was a Charleston landmark for 100 years. The hotel was once called the best place to eat between White Sulphur Springs and Cincinnati. John F. Kennedy celebrated his victory in the 1960 West Virginia primary in the hotel's ballroom. The grand old hotel is shown here on a card postmarked in 1908.

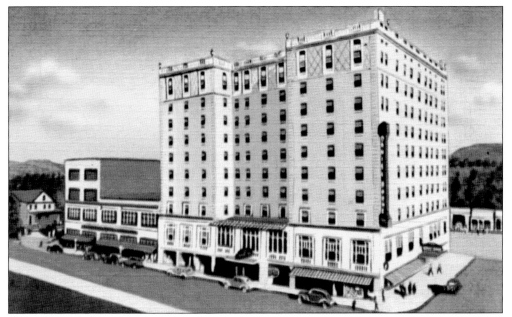

The Daniel Boone Hotel in Charleston was always a busy place, but never more so than when the West Virginia Legislature was in session. The hotel was the unofficial headquarters for lobbyists and legislators alike. Long closed as a hotel, the building was converted to house offices.

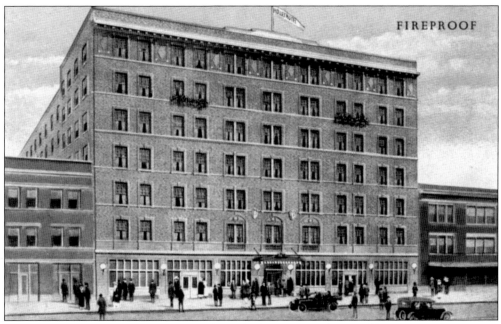

This card boasted that the Holley Hotel in Charleston was "fireproof."

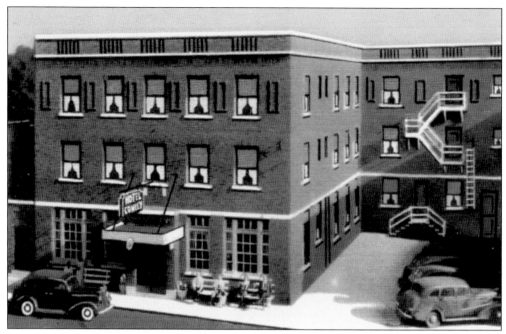

This undated card informed travelers that the Conley Hotel at Gauley Bridge on U.S. 60 offered "52 All Outside Rooms," with "Tile Baths" and beds "Equipped with Simmons Beautyrest Box Springs and Mattresses." It had all this and "Reasonable Rates" as well.

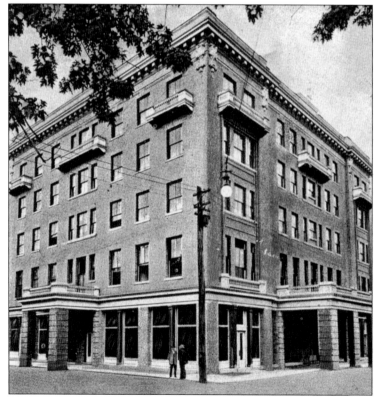

Here is the Hotel McCreery on 2nd Avenue in Hinton. The "R.P.O." in the 1908 postmark on this card indicates it was sorted by a clerk aboard a Railway Post Office car.

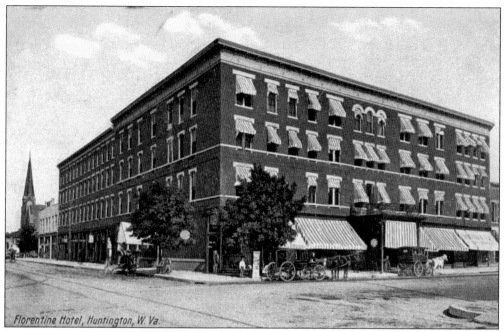

Florentine Hotel, Huntington, W. Va.

In Huntington's earliest years, one of the city's finest hotels was the Florentine, which opened in 1887 at the corner of 4th Avenue and 9th Street.

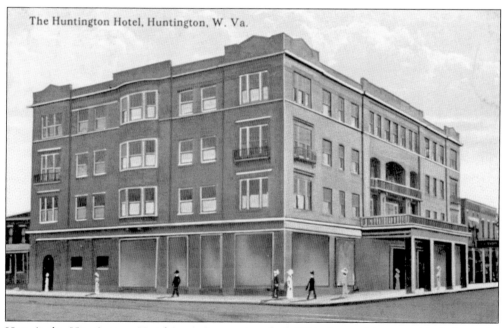

The Huntington Hotel, Huntington, W. Va.

Here is the Huntington Hotel in a view postmarked 1914. Located just one block from the C&O depot, the Huntington was a favorite among rail travelers.

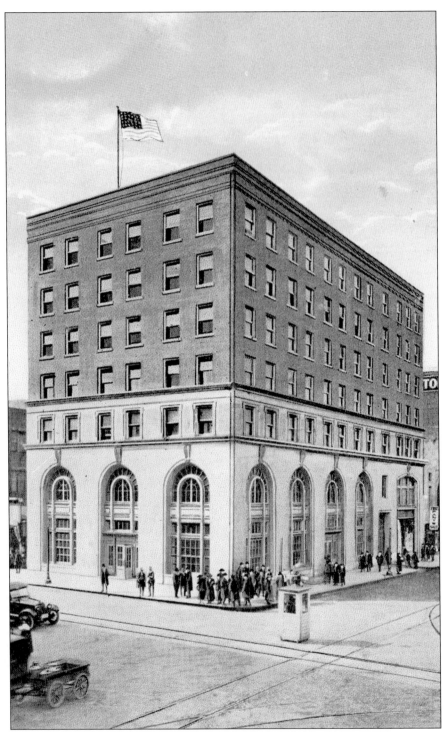

The Hotel Farr at 4th Avenue and 9th Street in Huntington was built in 1915. In the 1930s, it became the Hotel Governor Cabell. Note the booth in the middle of the intersection, apparently erected to shelter a traffic policeman.

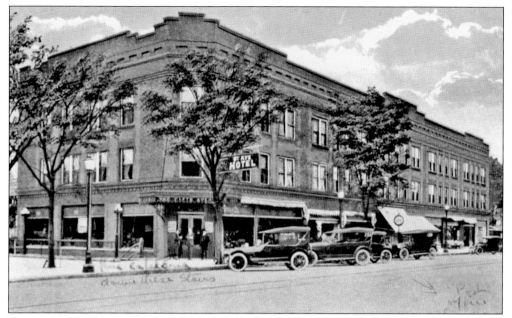

Huntington's Fifth Avenue Hotel was built in 1910 on the corner of 5th Avenue and 9th Street. In 1916, the hotel added what became Bailey's, a popular cafeteria. The cafeteria moved to 9th Street in 1936, just in time to be hit by the 1937 flood. This view of the hotel was postmarked in 1920. Today, the building is used for low-income housing.

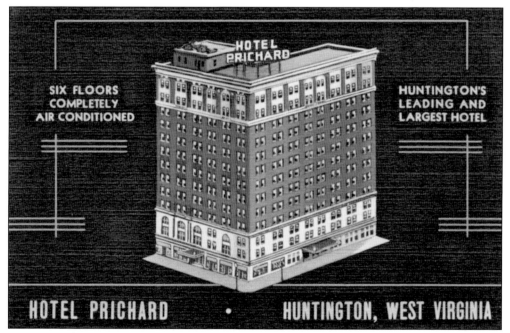

In a view that appears to date from the 1930s or perhaps the 1940s, the Hotel Prichard proclaimed itself as "Huntington's Leading and Largest Hotel," with six of its dozen floors "completely air conditioned." According to the advertising message on the back of the card, rates were $2.50 and up.

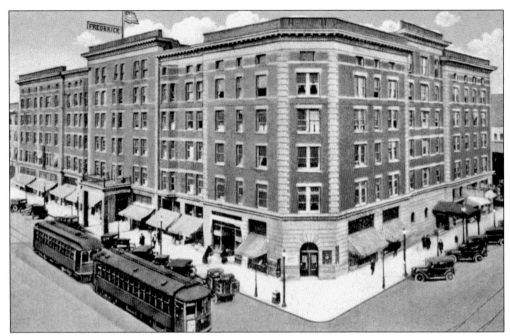

Built at a cost of $400,000, Huntington's grand Hotel Frederick welcomed its first guests in 1906. Its construction is said to have required 3.5 million bricks; 4,000 electric lights; 282 miles of electrical wire; 200 telephones; and 5 railroad cars of glass. This view was mailed in 1922.

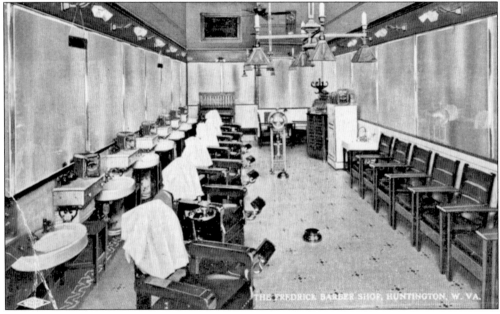

Like other major hotels of the day, the Frederick offered guests a broad range of services, including this well-equipped barbershop. Six barber chairs suggest what must have been a busy trade. Not only hotel guests, but also many of the city's businessmen no doubt patronized the shop.

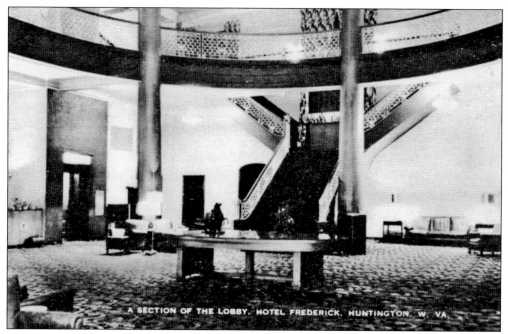

This 1949 lobby view attests to the fact that the Frederick was still a handsome place even during its declining years. One of the lobby's most striking features is not visible here—a stained-glass skylight at the center of the lobby's two-story rotunda.

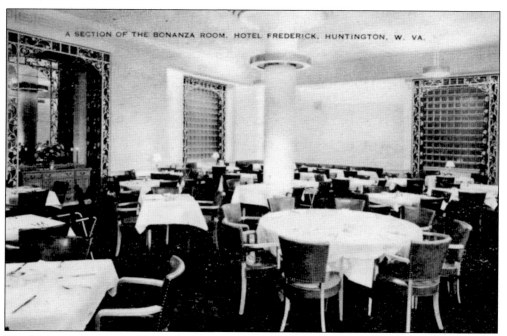

The Bonanza Room at the Frederick was a popular luncheon spot. The Georgian Terrace, located on the mezzanine, was the scene of countless private parties and receptions over the years. The hotel ceased operation in 1973. Today, the building houses offices and retailers.

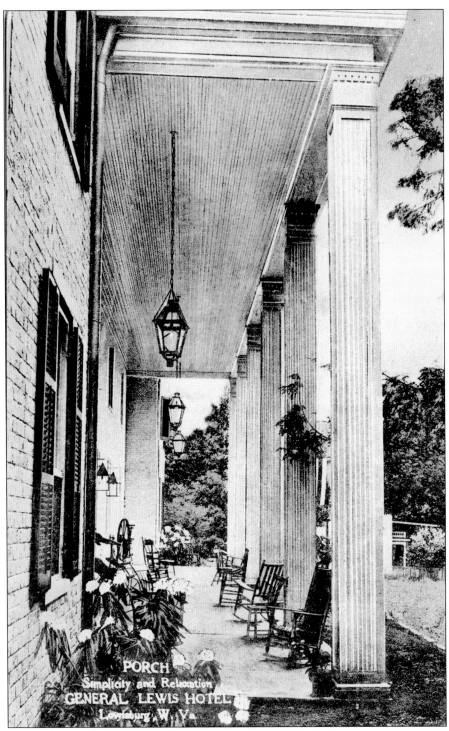

The General Lewis Hotel in Lewisburg, the oldest part of which dates back to 1824, still welcomes guests. Its rooms are furnished with antiques and collectibles, but in a concession to modern tastes, each also offers a TV and private bath.

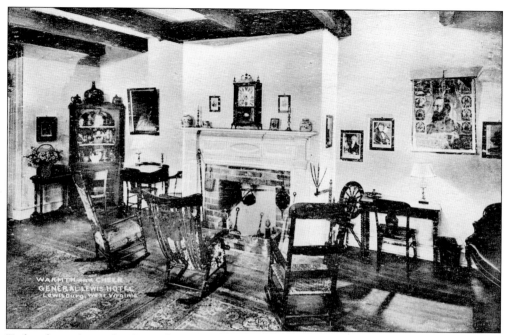

Today the parlor at the General Lewis Hotel remains mostly unchanged from how it looked in this view, mailed in 1944. Next to the parlor is the dining room, known for its old-fashioned, home-cooked fare.

Postmarked in 1945, this card shows the Virginian Hotel in Princeton.

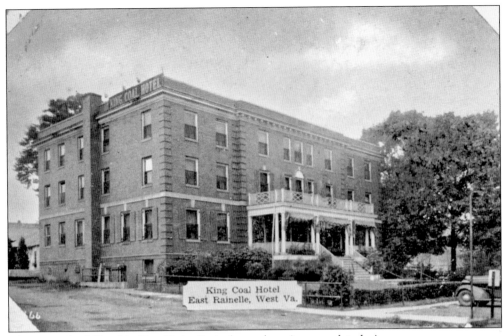

The King Coal Hotel in East Rainelle is shown here in an undated view.

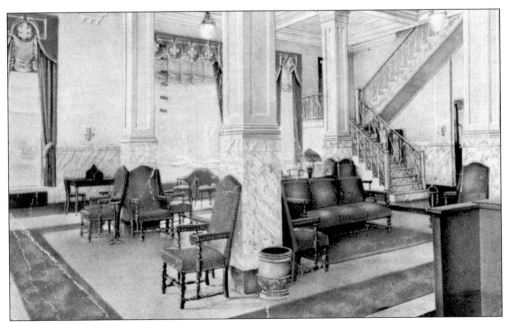

Mailed in 1926, this card features the lobby of the Hotel Carter in Welch.

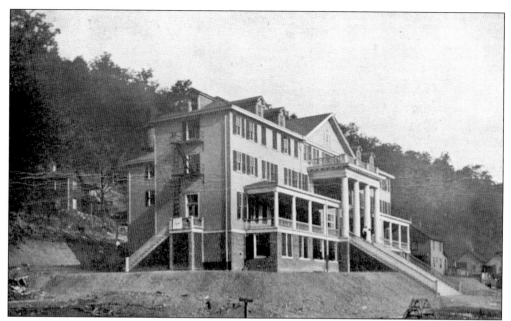

Railroad YMCAs provided inexpensive housing and recreational facilities for rail crews. Here is the rambling structure that housed the N&W YMCA at Williamson.

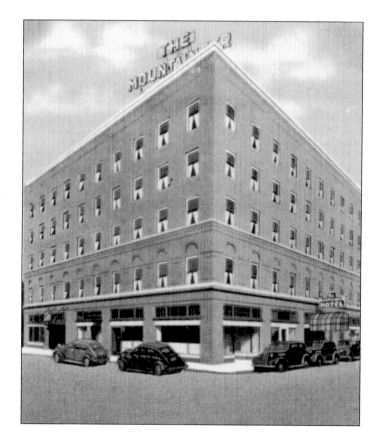

In the advertising blurb on the back of this undated card, the Mountaineer Hotel in Williamson informs travelers that it is "One of West Virginia's Finer Hotels."

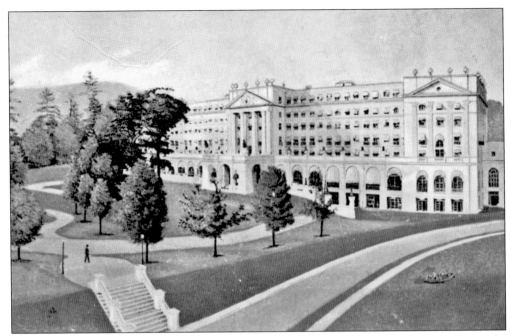

No survey of Southern West Virginia hotels would be complete without including The Greenbrier, one of the world's premier resorts. The "Old White" Hotel was a popular spa in the years prior to the Civil War and the arrival of the C&O in 1879 brought an influx of additional guests. In 1910, the C&O purchased the resort and in 1913 built the central seven-story section of the present building. This view was mailed in 1921.

The Greenbrier's famous springhouse may have been built as long ago as 1815. A newspaper clipping found hidden within its columns tells about Gen. Andrew Jackson's famous victory over the British at New Orleans.

# *Seven*

# PUBLIC BUILDINGS

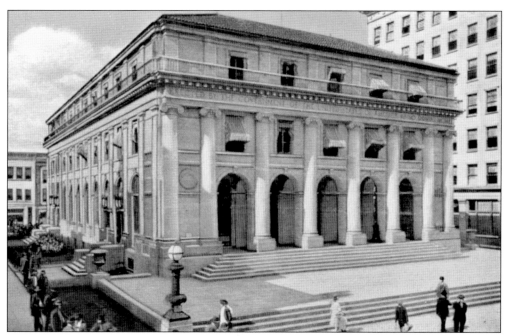

The Charleston Post Office and Federal Building was built in the state's capital city in 1911. Since 1967, the building has been home to the Kanawha County Public Library.

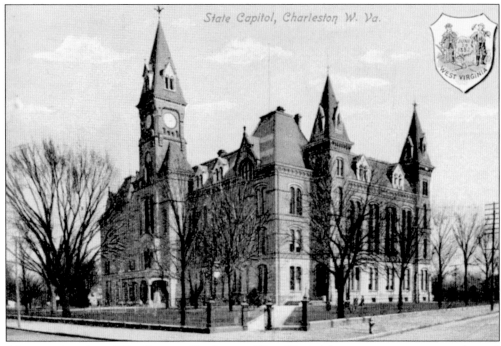

State Capitol, Charleston W. Va.

After moving from Wheeling to Charleston, West Virginia's state government was housed in this brick building, which burned in 1921. State government then moved into temporary, makeshift quarters, dubbed the "Cardboard Capitol." Ironically it, too, would be destroyed by fire in 1927.

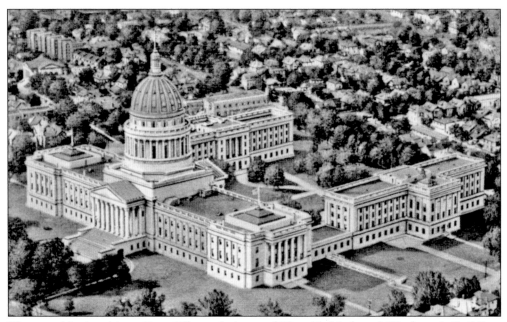

The state hired architect Cass Gilbert, designer of New York's famed Woolworth Building, to design a new capitol. It was built in stages, with the last portion, topped by a soaring gold-covered dome, dedicated in 1932.

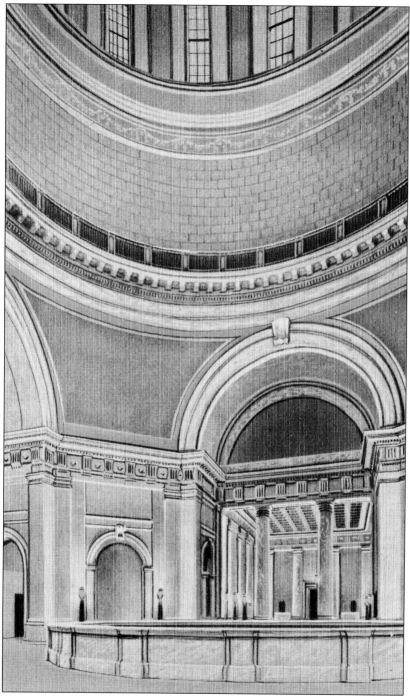

West Virginia's new capitol cost $10 million and many thought it was outrageous for the state to spend that kind of money on a building at a time when West Virginians, like other Americans, were coping with the ravages of the Great Depression. But the money proved a wise investment. The majestic structure has served the state well and each year attracts thousands of admiring visitors.

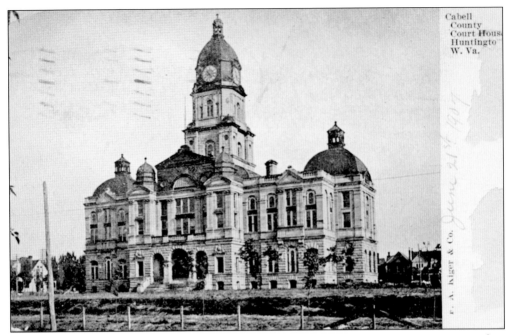

When the county seat was moved from Barboursville to Huntington, county government first shared use of the city building and jail. The county immediately purchased a square block of land and set about building a handsome courthouse. The original structure was completed in 1901 and is shown here on a 1907 postcard. East and West wings were added later.

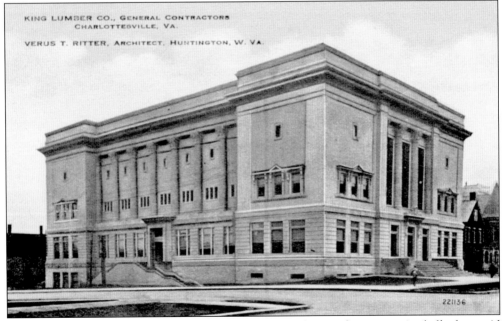

In 1911, when the city fathers in Huntington purchased a site for a new city hall, they paid the then-unheard-of sum of $48,000 for it. The King Lumber Company of Charlottesville, Virginia, won the construction contract with a bid of $115,380. Verus R. Ritter, who also designed a number of other buildings in early Huntington, was the architect.

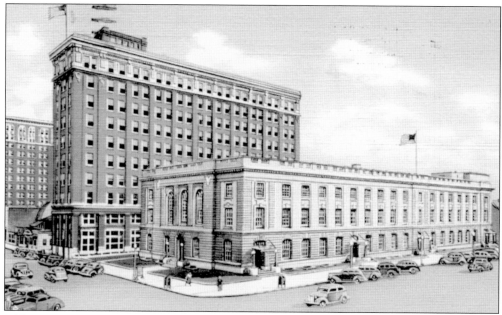

Although even a close examination does not reveal it, the old Huntington Post Office was built in three stages. The original building was constructed in 1907, the first addition in 1919, and the second in 1927. Today, the building—shown in a card postmarked 1940—houses the United States District Court and various federal offices.

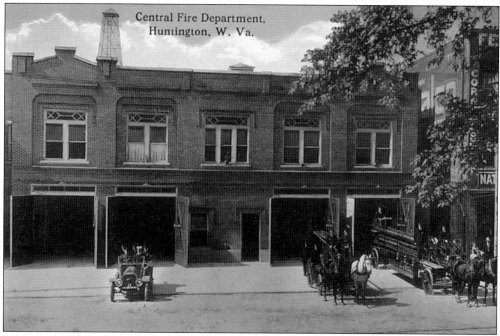

The Huntington Fire Department's Central Station is shown here in a 1915 view. Note the horse-drawn fire equipment. Central Station would remain in use long after the department's horses were put out to pasture. It would not be replaced until the 1970s.

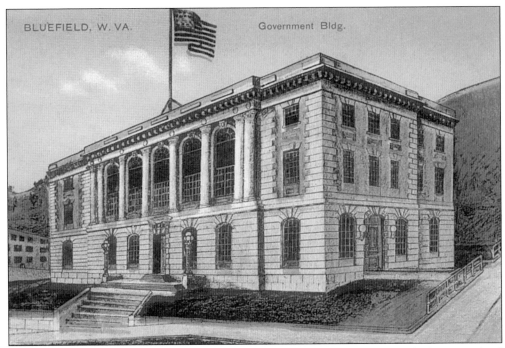

Originally built as the Bluefield Post Office, this structure is today the Elizabeth Kee Federal Building. Over the years, three members of the Kee family—John, his wife Elizabeth, and their son John—served the Bluefield area in the United States House of Representatives.

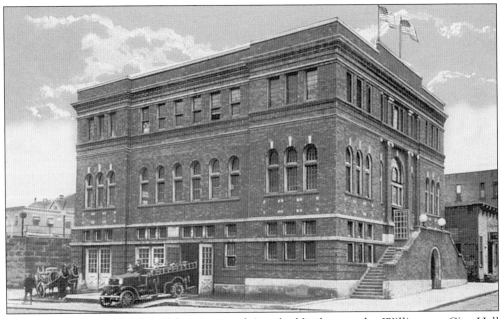

This three-story red brick building is seen doing double duty as the Williamson City Hall and Fire Department. The card is undated, but the fire equipment appears to date from the 1920s.

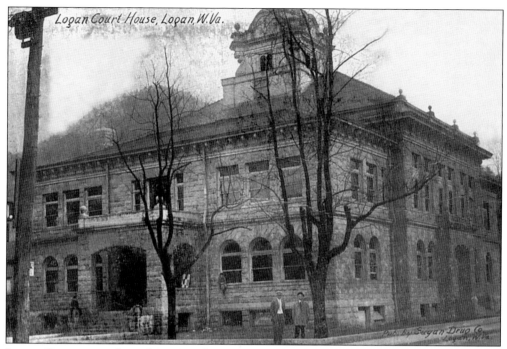

Logan County was formed in 1824 from portions of Cabell, Kanawha, Giles, and Tazewell Counties. It was named for Logan, the famous chief of the Mingo Indians. This view of the Logan County Courthouse is postmarked 1912.

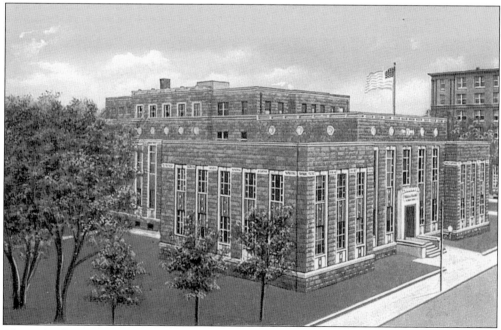

The Raleigh County Courthouse, designed by architect L.T. Bengton in the postmodern style, was built in 1937 as a Depression-era Works Progress Administration project.

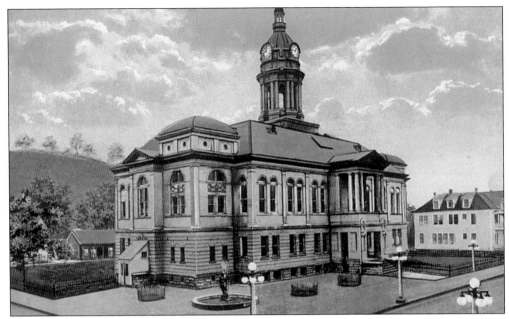

Mingo, the youngest county in West Virginia, was formed from Logan County in 1895 and named for the Mingo Indians. Shown here is an undated early view of the ornate Mingo County Courthouse.

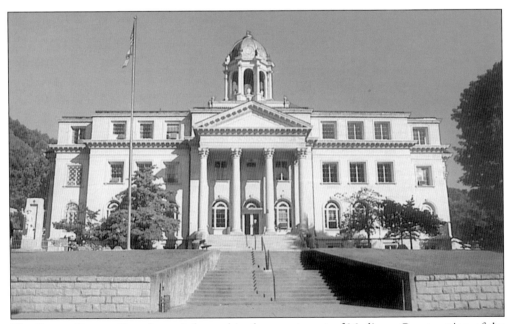

The Boone County Courthouse is located in the county seat of Madison. Construction of the handsome stone structure began in 1919 and was completed two years later.

*Eight*

# HOSPITALS AND CLINICS

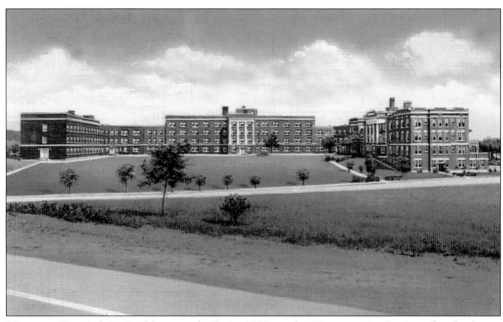

Pinecrest Hospital in Beckley was built in 1930 as the Pinecrest Sanitarium for the long-term, inpatient treatment of tuberculosis. With the decline in the incidence of tuberculosis, the state-run facility shifted its mission and today offers intermediate long-term care for its predominantly geriatric residents.

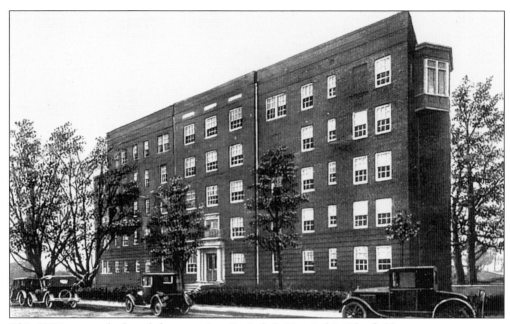

This 1927 postmarked card shows a view St. Luke's Hospital in Bluefield.

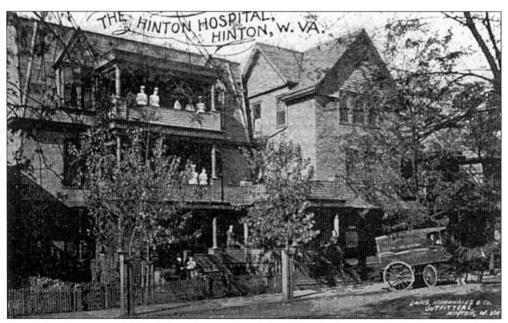

Dr. O.O. Cooper established the Hinton Hospital at Temple Street and 4th Avenue in 1899. Note the horse-drawn ambulance at the lower right of the card and the nurses gathered on the porches.

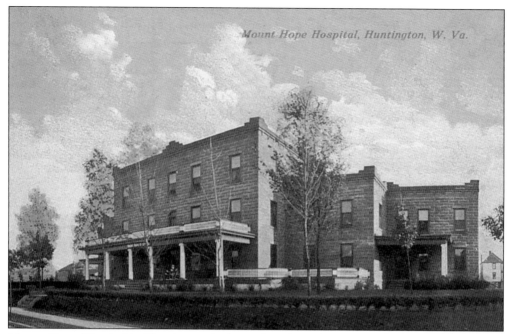

Mount Hope Hospital in Huntington is shown here in a view postmarked 1914. In a note on the card, the sender tells a friend in Parkersburg that "this is a beautiful town and we think we are going to like it."

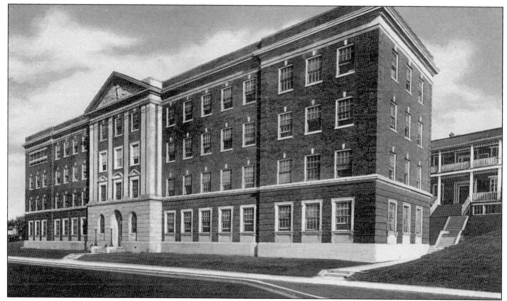

In an era when medical care was sometimes hard to find, the C&O Railway opened hospitals for its employees and their families. The first was established in Clifton Forge, Virginia, in 1897 and the second in Huntington in 1900. It is shown here in a vintage 1940s card. After the C&O closed its hospitals, the Huntington building was used to house offices and clinics for the Marshall University School of Medicine. It has now been demolished.

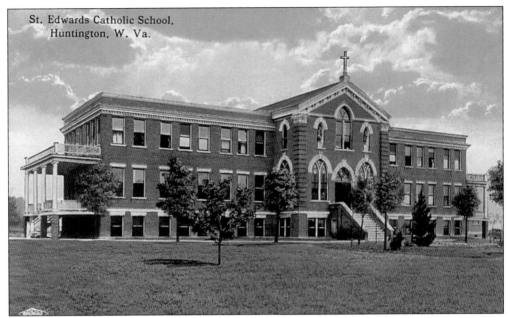

St. Edwards Catholic School,
Huntington, W. Va.

In 1924, Bishop John J. Swint invited the sisters of the Pallotine Missionary Society to open a hospital in Huntington. The decision was made to use this building, which had previously housed a failed Catholic school for boys. The 35-bed St. Mary's Hospital opened its doors on November 6 of that year.

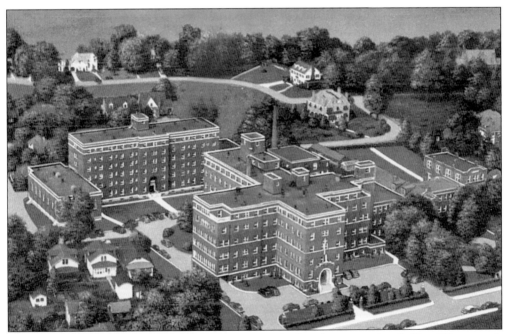

By 1949, years of steady expansion at St. Mary's resulted in this impressive facility. The growth has continued since. Today, St. Mary's Medical Center offers a broad range of sophisticated medical care, is the second-largest hospital in West Virginia, and is the largest private employer in Cabell County.

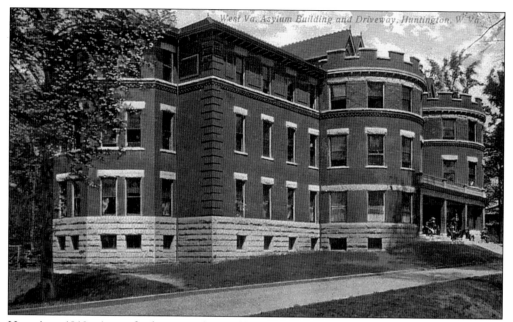

Here is a 1910 view of what was then called the West Virginia Asylum. Later known as Huntington State Hospital, the facility today is called the Mildred Mitchell-Bateman Hospital, renamed to honor a retired director credited with major advances in the care of the state's mentally ill. The hospital serves patients from 13 counties in Southern West Virginia.

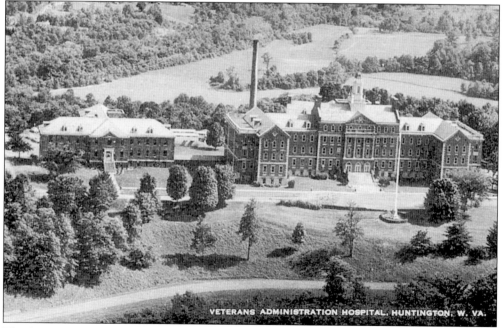

The Huntington VA Medical Center—better known to generations of vets as "the Veterans' Hospital"—is shown here in a vintage 1940s view. Today, it is a fully accredited, 80-bed acute medical and surgical care facility. It is the principal teaching facility for the Marshall University School of Medicine.

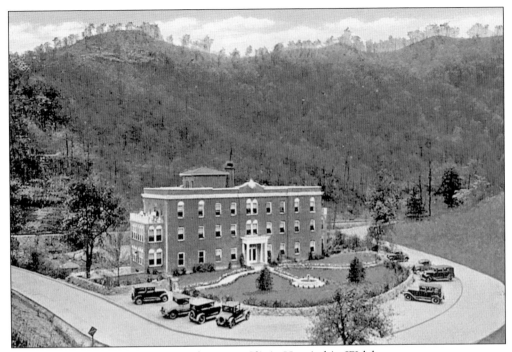

This card offers an undated view of Stevens Clinic Hospital in Welch.

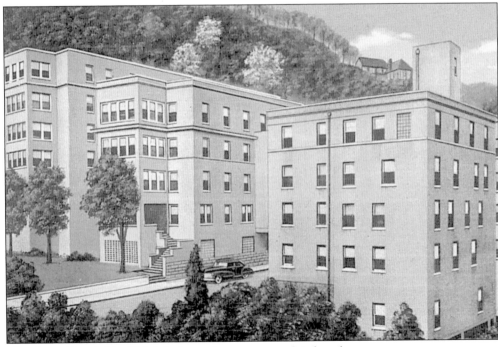

The Grace Hospital in Welch is shown here on an undated card.

*Nine*

# COUNTRY ROADS

John Denver could have had this unidentified mountain scene in mind when he sang about the country roads that would take him home to "Almost Heaven, West Virginia."

Pinnacle Rock State Park near Bluefield marks the eastern boundary of the state's Southern coalfields. This undated view illustrates how the park got its name.

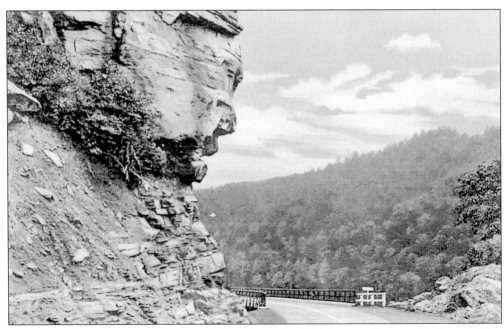

New Hampshire has its Old Man of the Mountain (which recently crumbled) and West Virginia has its Old Man of the Canyon, a strangely shaped rock formation at Routes 19 and 21, between Chimney Corner and Cotton Hill on the New River.

Chimney Corner, located near Gauley Bridge, has long been a landmark on the Midland Trail (Route 60), once the "superhighway" between White Sulphur Springs and Charleston.

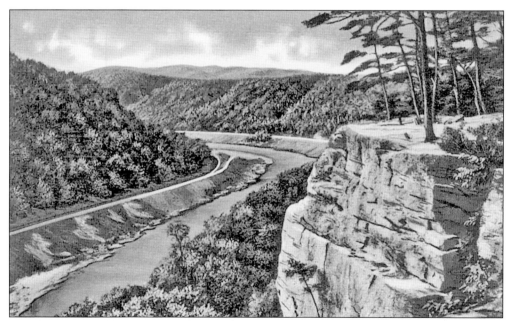

Here is another view from the Midland Trail, this one showing Lover's Leap, near Anstead. Originally called New Hope, the little community changed its name in 1861 after British coal speculator David T. Anstead purchased much of the nearby land.

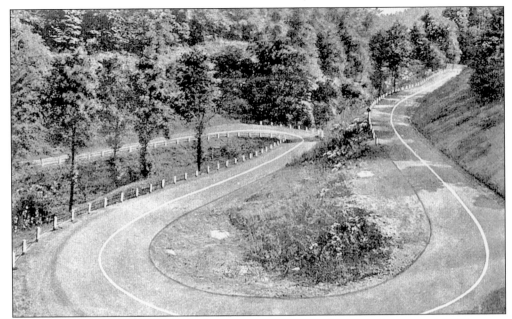

This 1945 view of a double horseshoe curve on Route 52, between Logan and Williamson, gives a good idea of the challenges road-builders face in West Virginia.

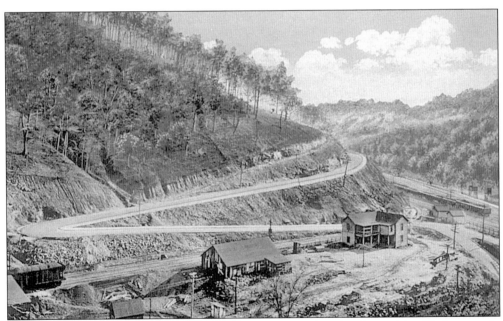

Here is a hairpin curve in a road that has been carved into the side of an unidentified mountain near Williamson. A waiting string of coal cars can be seen in the distance.

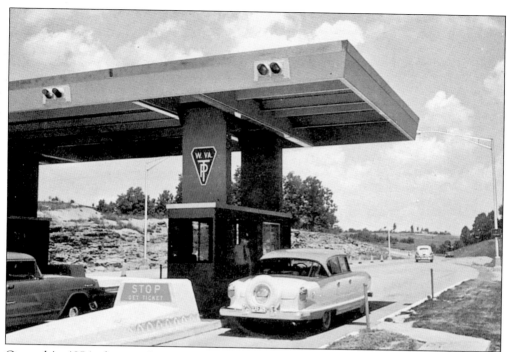

Opened in 1954, the two-lane West Virginia Turnpike was an engineering triumph, but an economic disaster. Traffic for the toll road fell far short of projections, primarily because it linked up with no other significant highways. But with the coming of the interstate system, the turnpike became a busy north-south artery.

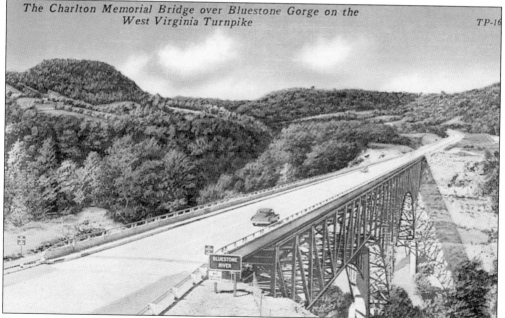

*The Charlton Memorial Bridge over Bluestone Gorge on the West Virginia Turnpike*      TP-16

The West Virginia Turnpike's Charlton Memorial Bridge was named in honor of Sgt. Cornelius Charlton, a posthumous winner of the Medal of Honor. The bridge towers 246 feet over the beautiful Bluestone Gorge below.

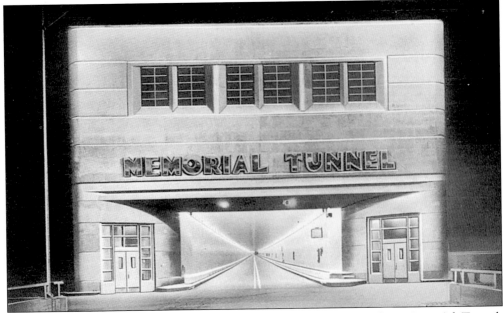

A highlight of the original West Virginia Turnpike was the 2,600-foot Memorial Tunnel, dedicated to all West Virginians who served in the military. When the turnpike was upgraded to four lanes—a mammoth $683 million undertaking completed in 1987—the tunnel was bypassed and closed.

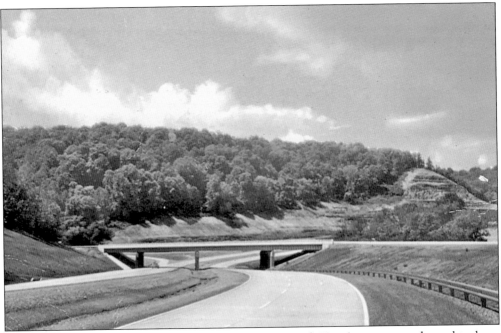

With the construction of Interstate 64, Charleston and Huntington were brought closer together than ever. This view of I-64 is not dated, but it must have been taken before it was opened to traffic. Today, the busy roadway is clogged with cars and trucks at all hours of the day and night.

## *Ten*

# MORE MEMORIES

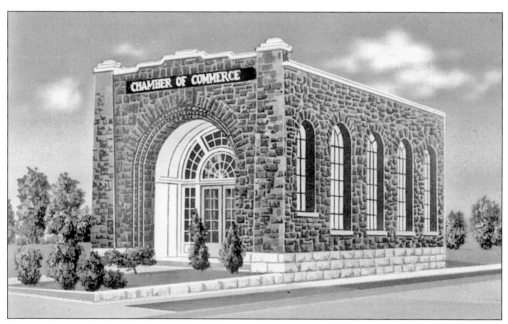

In 1933, when the Tug Valley Chamber of Commerce in Williamson decided it needed a headquarters building, it elected to build it out of coal—65 tons of it. The decision seemed, if unusual, nevertheless appropriate. After all, without coal, there might never have been a Williamson.

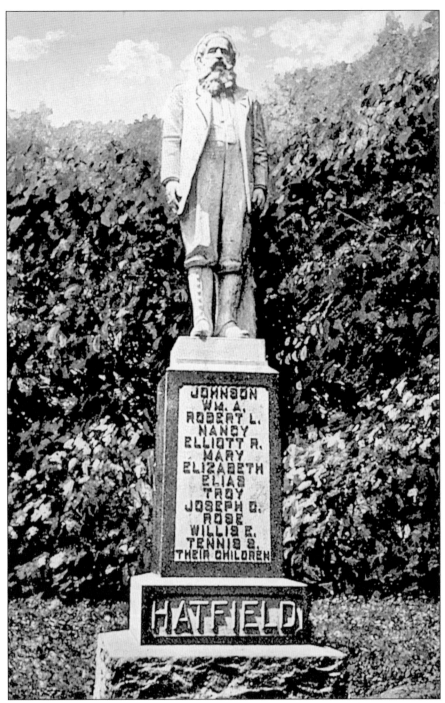

JOHNSON
WM. A.
ROBERT L.
NANCY
ELLIOTT R.
MARY
ELIZABETH
ELIAS
TROY
JOSEPH D.
ROSE
WILLIS E.
TENNIS S.
THEIR CHILDREN

HATFIELD

The Hatfield Cemetery on Route 119, south of Sarah Ann in Logan County, is the burial place of the Hatfield clan, including many of the participants in the famed Hatfield-McCoy feud. The grave of the family patriarch, Capt. Anderson Hatfield, better known as "Devil Anse," is marked by this life-sized statue. The bloody feud, which raged for years, is said to have originated in a dispute over the ownership of a razorback hog.

Julie Neal Jackson, the mother of famed Confederate Gen. Thomas "Stonewall" Jackson, is buried at Westlake Cemetery at Anstead on the Midland Trail (Route 60).

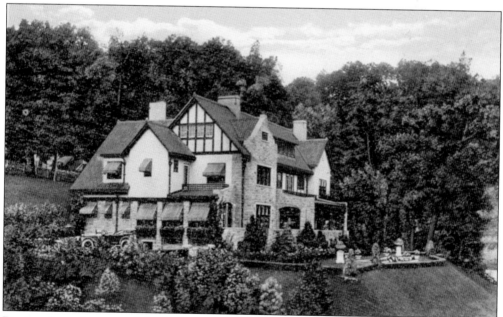

During the early years of the 20th century, the town of Bramwell was home to more than a dozen millionaire mine owners who built elaborate houses such as this one, the home of Col. W.H. Thomas. The coal barons' mansions, some of which still survive, offer dramatic evidence of the wealth the coalfields generated for the favored few in control.

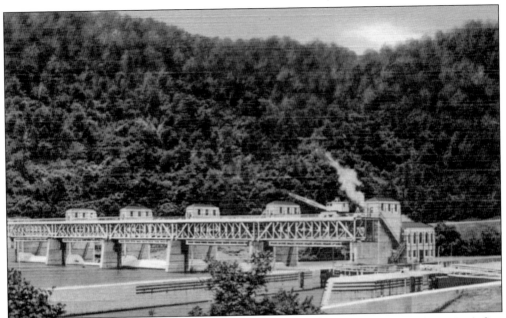

With the completion of 10 locks and dams in the 1890s, the Kanawha became the nation's first river system to have a complete navigation system, but by the 1920s, the system was inadequate and obsolete. So in the 1930s, the army corps of engineers replaced the old dams with three modern roller-type dams at Winfield, Marmet, and (shown here) London.

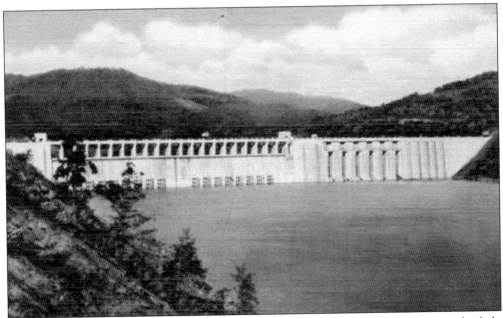

Many people mistakenly believe that the locks and dams on the Ohio and Kanawha help control floods. In fact, their sole purpose is to create a steady flow of water, thus making the rivers navigable at all times. Flood control dams, such as the Bluestone Dam at Hinton, are perched high in the hills, where they regulate the flow of water from the artificial lakes they create.

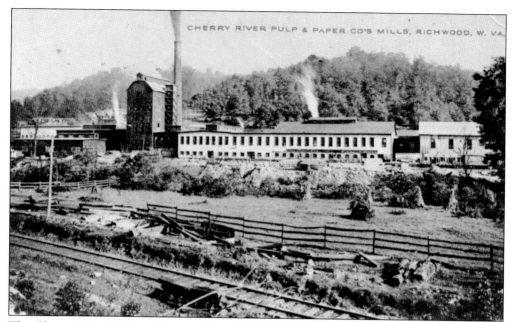

The Cherry River Pulp & Paper Mill at Richwood was commonly called the "Big Mill" by town residents. Although the postmark on this old card is illegible, a comparison with later photographs suggests that this shows the original mill before it burned in 1924 and was rebuilt. In 1929, this mill and a smaller, nearby mill together cut more than 100 million board feet of lumber.

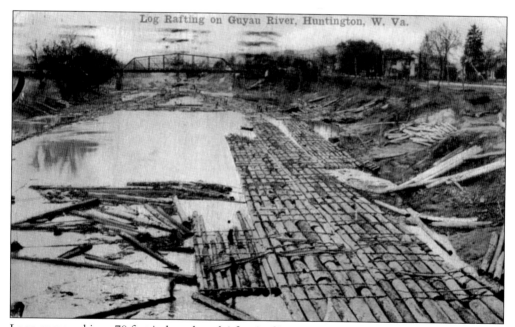

Logs, some as big as 70 feet in length and 4 feet in diameter, were floated down the Guyandotte River to Guyandotte, a village that was later absorbed into Huntington. There, the logs were sorted, measured, identified, paid for, and readied for the nearby sawmills. Those not sent to the local mills were lashed together and floated on down the Ohio River.

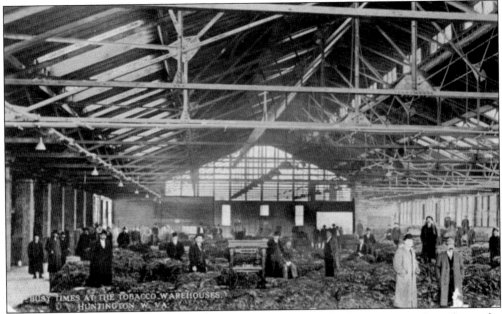

Although tobacco was never grown in Southern West Virginia in the same quantity as in nearby Kentucky or Virginia, it nonetheless provided a welcome bit of extra cash for many families. It was cut, hung from the barn rafters to cure, and then hauled by wagon—or later truck—to a warehouse for sale. This view of a Huntington tobacco warehouse is postmarked 1914.

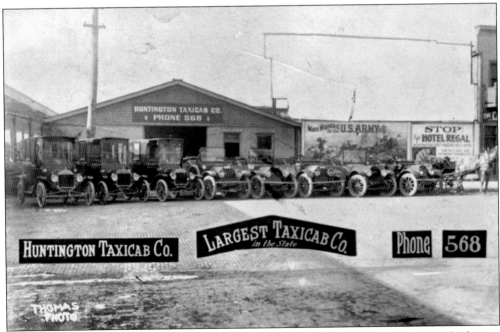

In this advertising card, the Huntington Taxicab Co. proudly boasted that it was the largest taxi company in the state. The card is undated, but the fleet on display—three closed cars and five open-air models, along with a horse and buggy—suggests the 1920s. Note the billboard behind the parked cars with a recruiting poster for the U.S. Army. It says "Men Wanted."

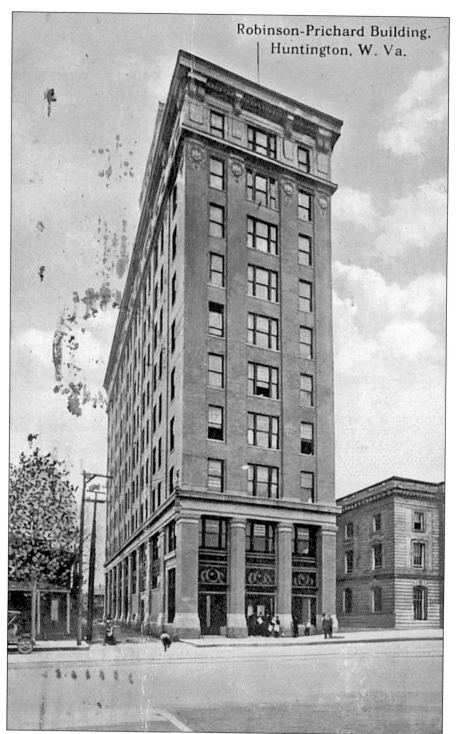

Robinson-Prichard Building,
Huntington, W. Va.

A number of coal companies leased office space in Huntington's Robinson-Prichard Building, completed in 1911 and shown here in a 1912 view. In the years since, the building has had a number of owners and names. Today, it is home to the Guaranty Bank & Trust Co.

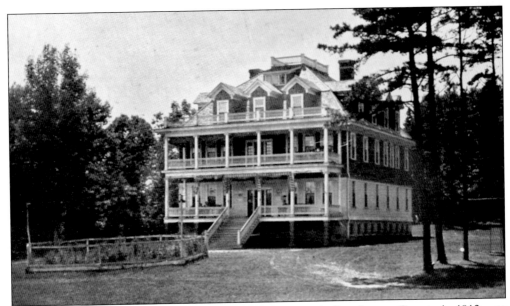

The Allegheny Club, which opened at Minnehaha Springs in Pocahontas County in 1912, was once a popular resort hotel. A number of animals, including a herd of elk, roamed the resort's original 5,000 acres. A newspaper article of the day described the clubhouse as "handsome and commodious." It burned in 1983.

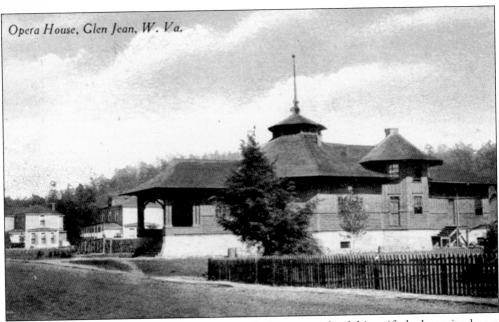

*Opera House, Glen Jean, W. Va.*

Thomas McKell came to Fayette County to look at some land his wife had received as a wedding present from her father. He stayed to become a prosperous coal operator. Among his ventures were the construction of the Opera House at Glen Jean, built in 1896 and shown here in an early undated view, and Thurmond's Dunglen Hotel. Reportedly, the Dunglen's bar never closed from the time the hotel opened in 1901 until 1914, when state prohibition took effect.

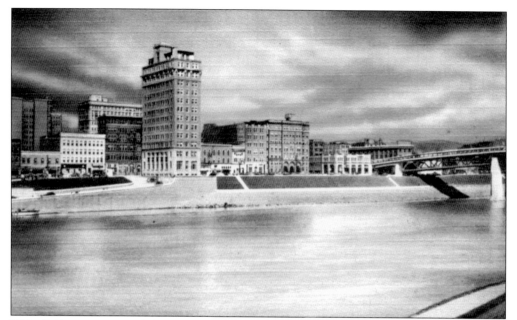

This 1940s or 1950s card depicts a view of the Kanawha River at Charleston. An unknown artist hand-colored the card to give the appearance of a sunset view. There is, however, just one problem: the artist has the sun setting in the east.

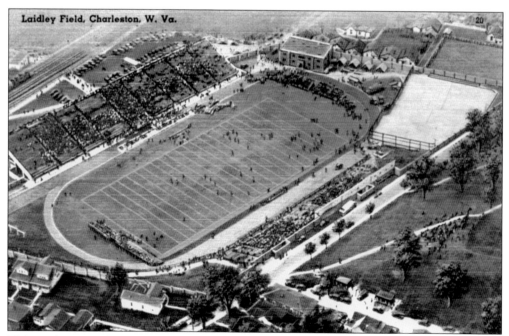

Laidley Field, Charleston, W. Va.

This card was mailed from St. Louis to an address in Philadelphia in 1946. The scene shown on the card, Laidley Field, has been a Charleston landmark since the 1920s. The field, which was equipped in 1938 with lights for night games, remains in use today.

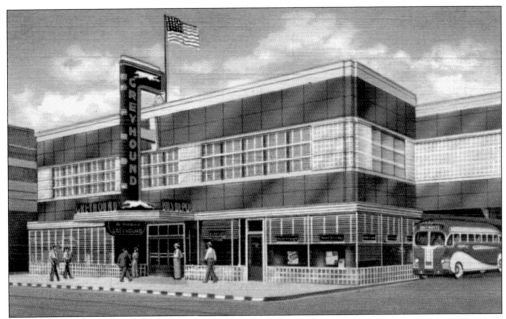

Greyhound buses were once a familiar sight on roadways throughout Southern West Virginia. Today, they have all but vanished. Here is a view of Greyhound's handsome art deco style bus depot on Charleston's Capital Street, a stopping point for many riders traveling to or from Southern West Virginia.

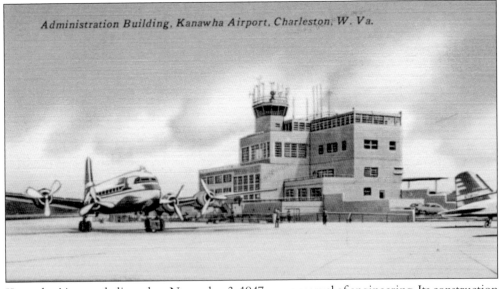

*Administration Building, Kanawha Airport, Charleston, W. Va.*

Kanawha Airport, dedicated on November 3, 1947, was a marvel of engineering. Its construction required the leveling of three hilltops on Coonskin Ridge, just north of downtown Charleston, and the filling in of the intervening valleys. In all, more than nine million tons of earth had to be moved. In 1985, the airport was renamed Yeager Airport in honor of famed airman Chuck Yeager, a native of nearby Lincoln County. In 1947 Yeager became the first man to fly faster than the speed of sound.